ℛEMEMBERED *in* BRONZE *and* STONE

Alan Livingstone MacLeod

REMEMBERED

in BRONZE

and STONE

CANADA'S GREAT WAR MEMORIAL STATUARY

foreword by David Macfarlane

VICTORIA | VANCOUVER | CALGARY

Heritage House Publishing Company Ltd.
heritagehouse.ca

CATALOGUING INFORMATION AVAILABLE FROM LIBRARY AND ARCHIVES CANADA

978-1-77203-152-2 (pbk)
978-1-77203-153-9 (epub)
978-1-77203-154-6 (epdf)

Copyediting by Kari Magnuson
Proofread by Karla Decker
Cover and interior book design by Jacqui Thomas
Cover photos by Alan MacLeod: Emanuel Hahn, Fernie, British Columbia (*front*),
 and Emmanuel Hahn, Westville, Nova Scotia (*back*)
Interior photos by Alan MacLeod, unless otherwise indicated
Map by Eric Leinberger

Heritage House is committed to reducing the consumption of old-growth forests in the
books it publishes and makes every effort to print its books on environmentally friendly,
post-consumer recycled paper.

We acknowledge the financial support of the Government of Canada through the Canada Book
Fund (CBF) and the Canada Council for the Arts, and the Province of British Columbia through
the British Columbia Arts Council and the Book Publishing Tax Credit.

20 19 18 17 16 1 2 3 4 5

Printed in China

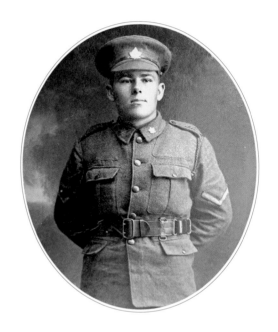

In memory of No. 716207,
Harrison Lincoln Livingstone, who inspired all of it

\mathcal{F} OREWORD

WAR MEMORIALS ARE A SERIES of questions. That's also what history is—more questions than answers, anyway. And so it's not surprising that the questions war memorials raise are historical in nature.

The questions memorials ask lead directly from now to then. And the backward journey embarked upon by anyone who pauses at the solemn statues that stand in so many little towns across Canada illustrates an important point: we are kidding ourselves if we think we are disconnected from the past.

Stopping to consider a war memorial in Canada (the National Inventory of Canadian Military Monuments lists thousands of them) always begins with the present. "What am I doing here?" is the first question I find myself asking. If I pause for a moment—as I sometimes do at a great-uncle's name among the long list of the University of Toronto's fallen at Soldier's Tower—I often wonder, "What exactly am I doing? Honouring? Mourning? Imagining? Feeling sad? Being patriotic? Getting angry?"

Probably all of the above.

This makes war memorials unsettling, no matter how modest or predictable they are. They make us uncomfortable—if only because we still live, feel dawn, see sunset glow. In other words,

9

they affect our present. But there's a broader context that is just as contemporary.

We stand in front of military monuments and we ask, "How respected or how ignored is a community's gesture of remembrance? How well are the memorial and its site maintained? Has the city, or town, or village in which statue, cairn, or plaque were erected continued to honour their presence? Does a memorial look like it's central to a community, or has it become a dusty artifact overshadowed by the present tense in which it exists? What can we learn about a place by considering how it attends to or ignores its own history?

What do military monuments tell us about the people who, after a war, fundraise to build them? What can we learn about the designers who conceive and the artisans who carve and cast them? In the case of the Great War, what do war memorials tell us about the citizens who have gathered in front of them on every November 11 (and, in the case of Newfoundland, every July 1) for the past century since the armistice was signed?

How did the view of the First World War change as generations passed? If we stand in front of the war memorial in Taber, Alberta, in 2016, are we seeing the war more clearly than those who gathered there for remembrance services seventy-five, or fifty, or twenty-five years ago? Or has time obscured our vision as much as grief coloured theirs?

Questions, questions, questions. And the biggest and the most troubling is the most obvious one: who were the people who are now represented by names on plaques or carved in stone?

Anyone who considers a war memorial almost automatically asks, "What was it like to be them, then, there?" Did they know they were going to die or, at the very moment of their deaths, were they still confident, as young people so often are, that they would be among those who would survive? And what would they—boisterous, reckless, irreverent, and probably more than a little cynical about the war—make of the monument on which their names are inscribed? Would they chuckle at the sonorous language of remembrance? Or would they feel that a dignified memorial of bronze or stone was, at the very least, their due?

It's not hard to ask these questions. Neither great skill nor education is required. War memorials, by their very nature, bring questions

to the minds of any who stop for a few moments to consider them. Asking is easy.

But answering these questions—now that's a different matter. Answering requires a much more focused response. Answering authoritatively, more focused still. Resourcefulness is required— the journalist's determination, the historian's rigour. Clarity is an obligation—the clarity of a good writer. And so is passion—the passion of someone who loves and understands the importance of a subject. Perhaps more than anything, though, curiosity is requisite. Curiosity, as Alan Livingstone MacLeod's remarkable and informative *Remembered in Bronze and Stone* makes clear, is the fuel of answers. We are fortunate MacLeod has paid such close attention to the questions our war memorials so stubbornly raise.

David Macfarlane

\mathscr{P}REFACE

FIFTY YEARS AFTER HE HAD left behind the trenches of Flanders and France, intact physically if not emotionally, Harrison Livingstone realized a dream. After decades of exile in cities—Detroit, Montreal, Halifax—my great-uncle returned to the land of his boyhood, his beloved Cape Breton Island, Nova Scotia. He acquired a big piece of land near Marble Mountain, at the far southwest corner of the Bras d'Or Lakes—five hundred acres, including an island all his own and five miles of shoreline. He was never happier.

Along with the land, he acquired a 140-year-old tumbledown house. In the spring of 1965, I went with my great-uncle to take the first steps in rehabilitating the ancient house. The attic was knee-deep in the lifetime detritus accumulated by the bachelor who had departed the place in old age and had sold it to Harrison. In the front room there was a wooden puncheon filled with pickled herring of unknown vintage.

Harrison was sixty-eight at the time; I was eighteen, the same age at which Harrison had gone off to war in 1916. We worked together cleaning up the house, cutting trails through his woods, making firewood. He sang the songs that he and his Twenty-Fifth Battalion comrades sang as they marched from one battleground to the next: "Keep the Home Fires Burning"; "There's a Long, Long Trail"; "It's a Long Way to Tipperary." No one else was about, and there were no distractions, not even a radio. We had only each other for company. Circumstances were ideal for what unfolded.

I managed to get Harrison to begin talking about his war—not just the rats and the lice, the cold and the mud, the perpetual fear of enemy shellfire, snipers or night-time raids, but particulars too. It was a half-century since his time in the trenches, but my great-uncle's memories were utterly vivid, as if the events he recalled had happened yesterday.

Memories of the platoon mate who chastised him for indulging in horseplay as the two young soldiers and a detail of others went into action, then, moments later, having the friend vaporized by a shell blast.

Memories of another platoon comrade who had "gone sweet" on a French girl and went AWOL to follow his bliss. Court-martialled for desertion, the friend was sentenced to be shot at dawn. Harrison was assigned the duty of standing guard over his comrade on the last night, warned that in the unhappy event of a prisoner escape, Harrison himself could look forward to facing a firing squad. Bad as that role was, there was one worse: at dawn a firing squad selected entirely from his own platoon took their positions and ushered their comrade to kingdom come. The friend, sixteen at the time of his enlistment, was an old hand of nineteen on his final morning.

Memories of his beloved brother, Daniel, who in April 1918 went missing in action during a scouting patrol into no man's land. Of parading before his battalion commander to beg permission to go in search of Daniel. Of being denied that permission. Of being instructed some time later to head directly to the military cemetery at Wailly Orchard, where Harrison watched as Daniel, wrapped in burlap, was hastily laid to rest with virtually no ritual.

Harrison's stories were riveting, mesmerizing, unforgettable. They have stayed with me over the course of the half-century that has passed since that memorable Marble Mountain spring. They have motivated thousands of hours of reading and research into the Great War and particularly Canada's part in it.

I was born three decades after the end of the war, but from an early age I was aware that the events of 1914–1918 cast a certain shadow over my Cape Breton family. Harrison had lost not just his brother but six cousins and uncounted numbers of friends.

There is an old photograph of my father and me standing at a war memorial in Dartmouth, Nova Scotia, a monument to the community's fallen erected by the Imperial Order Daughters of the Empire. In the

13

photo I am about four years old. I have been aware of the war and its influence for a long time.

For many years Harrison's influence remained largely latent. When I was finally emancipated from wage drudgery, opportunities arose to reawaken the interests he had sparked in that long-ago Marble Mountain spring. In the Internet age, I managed to track down artifacts—images, documents, relics—reflecting not just Harrison's time in the battlefields but that of his soldier brothers, cousins, and friends. Slowly I built an archive that helped reveal not just the war's effect on my uncle but on the whole Cape Breton community in which he grew up. Twenty-two young men of the community—Boularderie Island, Cape Breton—went off to war and never returned. To the extent I could, I told their stories through the archive, which I made available through the Internet.

In 2005 my wife, Jan, and I travelled the battlefields of Flanders and France by bicycle, with good friends. Seven of Boularderie's twenty-two lost soldiers were my relatives. I was lucky—all seven have known graves. We visited each of the graves and paid our respects in the beautiful and affecting cemeteries maintained by the Commonwealth War Graves Commission.

The enterprise in your hands is just another consequence of my uncle's Marble Mountain stories. In the summer of 2010, I happened to travel to Westville, Nova Scotia, on a war history mission. In a green space by the Westville post office, I chanced upon something that stopped me in my tracks. It was the Westville war memorial, the finest, most affecting I had ever seen. On its base was a mark: *E. Hahn Sc 1921*. In an instant, I had a new mission—to learn about "E. Hahn," who he was, what else he had done.

In the ensuing years, Jan and I have crossed Canada twice, choosing routes that would deliver us to as many stone and bronze war-memorial soldiers as we could arrange to see. We have made several regional trips too, all in aid of seeing war memorials featuring a soldier statue. Together we have seen, contemplated, and photographed the majority of such monuments in Canada. Those monuments, the artists who made them, the communities that erected them, and some of the people, both men and women, they are meant to remember and honour are the focus of this book.

Like all the other soldiers of the Great War, Harrison is gone.

His influence lives on. ✑

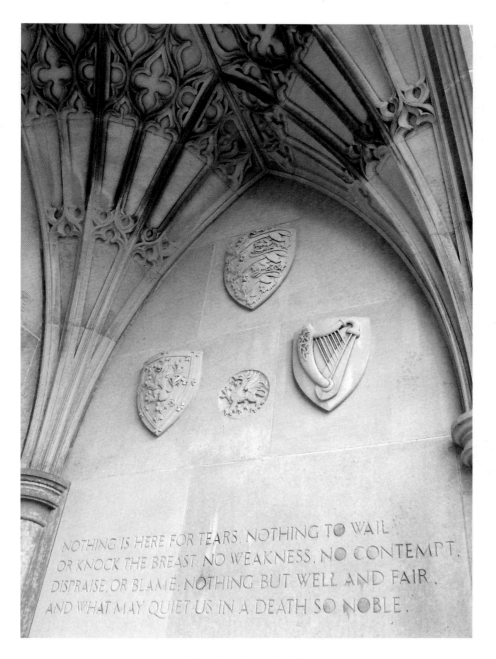

NOTHING IS HERE FOR TEARS, NOTHING TO WAIL
OR KNOCK THE BREAST, NO WEAKNESS, NO CONTEMPT,
DISPRAISE, OR BLAME, NOTHING BUT WELL AND FAIR,
AND WHAT MAY QUIET US IN A DEATH SO NOBLE.

▲ Soldiers' Tower, University of Toronto

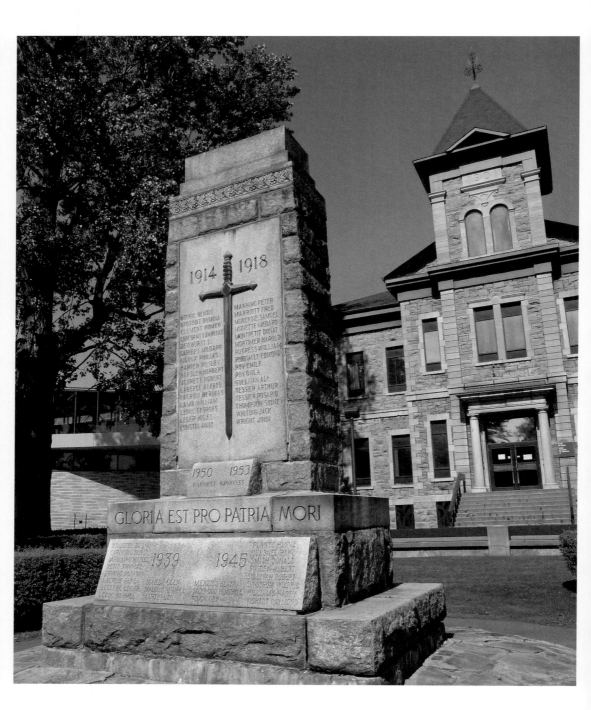

I

*I*NTRODUCTION

WHAT IS A WAR MEMORIAL? What are its specifications? What does it look like?

In Canada a war memorial can be an arena, clock, or museum. A hospital, column, or tower. A bridge, hall, or gun. An arch, park, or building. A wall, window, or street.

And many other things besides.

The National Inventory of Canadian Military Memorials provides more than 7,500 answers to the question "What constitutes a war memorial?" Some forms of war memorials in Canada are more numerous than others. At the time of writing, there is only one standing-stone war memorial, but eight hundred stones. Only four pyramids but 685 cairns. Some 2,043 Canadian war monuments are plaques, 688 are stelae, 516 are shafts, 319 are crosses, and 246 are obelisks.

The sixth-most-numerous type of war memorial in Canada is the statue, some 410 of the overall total.

This book will focus on statues, but not all of them. Some memorial statues are of angels, wraiths, or cherubs. Our subject is narrower than that—soldiers only. Angels, cherubs, and wraiths are typically, though not entirely, excluded from our purview.

The scope of this book is limited to those war memorials—a few more than two hundred in number—having a statue of a Canadian soldier of the Great War of 1914–1918. The field is further limited, by time, from those figures produced in the years immediately after the 1918 Armistice, to approximately the end of the 1920s.

This enterprise insinuates no slight against Celtic crosses, obelisks, or arches. We have encountered many in our travels that are highly worthy. A few of the alternatives to statues are exhibited in this chapter.

What is the duty of a war memorial? The proposition defended here is that a war memorial's core obligation is to evoke those who were lost with sufficient authenticity and conviction that we are moved to remember and honour them.

A bias is admitted right at the outset: it has been my experience that, generally speaking, those war memorials having a life-sized effigy of a Canadian soldier are the ones that most effectively meet the prescribed duty. No one has to agree with that view, but the reader must be prepared to encounter it throughout the chapters ahead.

Another bias: community war memorials that pledge to remember their fallen "for evermore" but offer no names for the visitor to contemplate are judged inferior to those listing the names of the lost. The highest-regarded are those community memorials that identify their fallen, with details—the soldiers' ages, the military units in which they served, the battles in which they fought, the dates on which they died.

What inspired this book? In 2010, while on a Great War–related history mission, I happened to chance upon a Nova Scotia war memorial that struck me as the finest, most affecting I had ever encountered. This monument—addressed at some length in Chapter IV sparked a mission: to learn more about the artist who created it and to see more of his work. One thing led to another. In 2011, my Jan and I decided to cross Canada, east to west, selecting a

◀ *LEFT* … Cherub, Echo Bay, Ontario

▼ *BOTTOM LEFT* … Stela, Rockwood, Ontario

▼ *BOTTOM RIGHT* … Obelisk, Kaslo, British Columbia

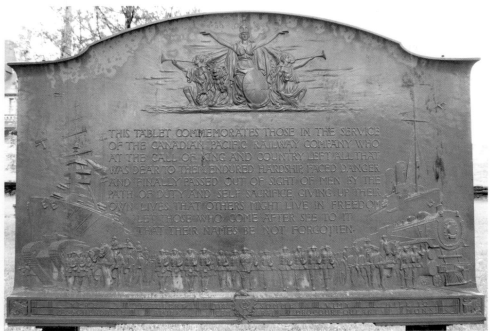

▲ *TOP* ... Bronze tablet, McAdam, New Brunswick

◄ *BOTTOM LEFT* ... Clock tower, Wainwright, Alberta

► *BOTTOM RIGHT* ... Cairn and gate, Princeton, British Columbia

meandering route meant to deliver us not simply to more work by the artist discovered the previous year but to the whole shebang—as many post–First World War stone and bronze soldiers as we could manage to see.

Then, eight months later, in 2012, we did it again, west to east this time, following a new route aimed at delivering us to other, different monuments. Further regional quests followed in 2013 and 2014. Indeed, the quest continues to this day, but the potential for new encounters diminishes—we have now seen, studied, and photographed a big majority of the entire field.

Serendipity was a constant companion in 2011 and in the years that followed. We frequently drew attention when we stopped to study a community war memorial. At Eugenia Falls, Ontario, we paused at the Beaver River Grill to ask for monument-finding advice. The friendly people there offered not just advice but an array of fresh preserves. Then and there, Jan decided the monument tour was a brilliant plan. At St. Claude, Manitoba, the mayor spotted us and provided valuable details about the restoration of his community's war memorial. At Holden, Alberta, a local amateur historian came out to see what we were up to. From him we learned about the history of the remarkable Holden monument.

I eventually put together an illustrated presentation on the subject of this book for the Western Front Association–Pacific Coast Branch. Then I delivered it for other organizations. The response was gratifying each time. Enthusiasts insisted I had to write a book. So I did. This is it.

Great War soldier statuary is distributed unevenly across the country. Approximately half of it—slightly more than a hundred figures—is found in Ontario. Manitoba and Nova Scotia also have concentrations; indeed, in per capita terms, Nova Scotia is blessed with more 1920s-era bronze and stone statuary than any other province.

The war was not embraced in Quebec as it was elsewhere in Canada, and the conscription crisis of 1917 very nearly split the country in two. Quebec's volume of statuary is accordingly far slighter than its population might lead one to expect. The provinces having the lowest numbers of 1920s statuary are the opposite-end jurisdictions: Prince

Edward Island, New Brunswick, British Columbia. Newfoundland was a separate Dominion at the time of the war and in the aftermath, until 1949. Further, very few of its 1920s-era community war memorials feature a soldier figure. Newfoundland is thus unrepresented in this project, except tangentially.

Close to half of the Great War memorial statuary in Canada is Italian-made Carrara marble. A small number of our bronze soldiers, fewer than a dozen, are made-in-America or made-in-UK figures. The remainder, eighty or so, are soldiers in bronze or stone designed by Canadian artists working in Canada. The plan of this book reflects that breakdown. Chapter II deals with Italian-made soldiers in Carrara marble. Chapter III addresses the comparatively small number of US- and UK-made figures. Chapter IV, the big one, surveys the broad spectrum of stone and bronze soldiers produced by Canadians.

We are now in the centenary years of the Great War. A century has passed—or is about to pass—since Canadians fought and died at Ypres, the Somme, Vimy, Passchendaele, Cambrai.

This book aims to introduce Canadians to their Great War memorial statuary. More than that, to the artists who created it. To the communities that brought it about. Above all, to just a few of the sixty thousand men and women who died in the war and were meant, through these monuments, to be remembered for evermore. ⟨∞⟩

Caribou, St. John's, Newfoundland

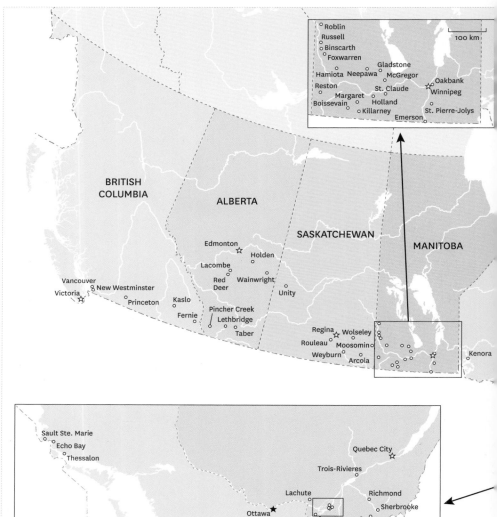
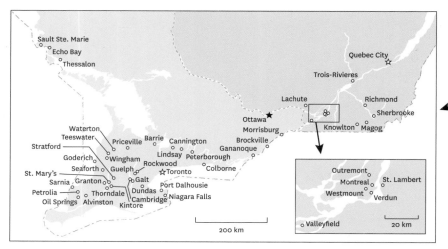

500 km

NEWFOUNDLAND AND LABRADOR

St. John's ☆

QUEBEC

ONTARIO

PEI

NB NOVA
 SCOTIA

Fort William
Thunder Bay

Sydney

PRINCE EDWARD
ISLAND

Malpeque Charlottetown ☆ Tatamagouche Canso
Summerside Pictou
 Pugwash New Glasgow
Moncton Westville
 Dorchester Amherst
NEW Springhill Great Village
BRUNSWICK Middle Musquodoboit
 Fredericton ☆
 Wolfville Halifax ☆ NOVA
McAdam Chester SCOTIA
 St. Stephen
 Digby
 Liverpool

 Yarmouth 100 km

FEATURED LOCATIONS

OF CANADA'S

GREAT WAR MEMORIAL

STATUARY

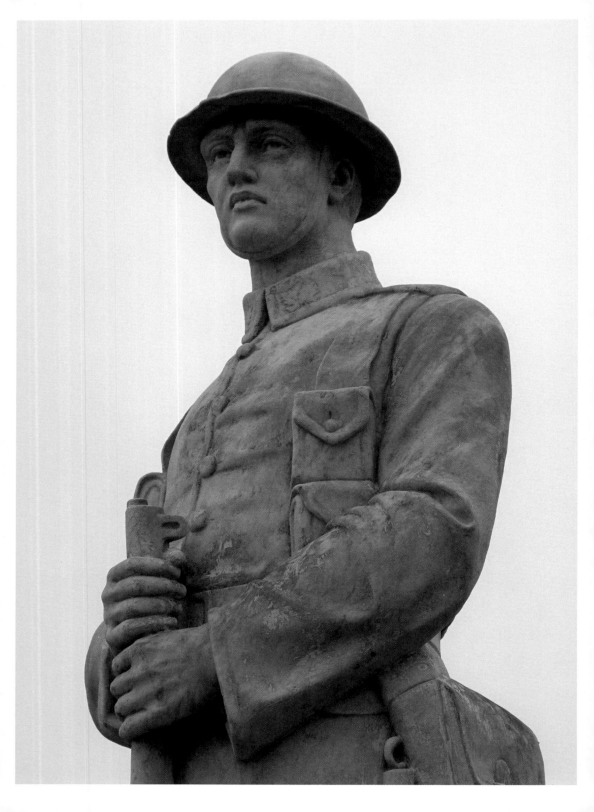

II

THE *Italian Connection*

FOXWARREN, MANITOBA, IS A TINY hamlet—population just a
couple of hundred souls—in the southwest corner of the prov-
ince, not far from the Saskatchewan line. A large welcome sign
at the entrance to Main Street, off Highway 83, proudly celebrates that
Foxwarren is the hometown of three hockey luminaries—Ron Low,
Pat Falloon, and Mark Wotton—who between them played a thousand
games in the National Hockey League. Beguilingly named, Foxwarren
is a typical prairie village. Main Street boasts a post office, Co-op gro-
cery store and cardlock, and a small roadhouse.

Foxwarren's Main Street is typical for something else: at a key
street junction, there is a little park with a monument. On the monu-
ment pedestal there is a soldier, of white stone, standing at attention.
Below the white-stone soldier on the polished granite panel are listed
fifteen names, names of the young men of Foxwarren and surrounds
who went off to war from 1914 to 1918 and never returned. Listed with

each name are the young soldier's battalion and the date he died. At the head of the list, these words: *Lest We Forget*. On an adjacent side of the pedestal is another list, of places rather than of men—Sanctuary Wood, Vimy Ridge, Lens, Passchendaele, Amiens, Cambrai—all of them storied places in Belgium and northern France where young Canadian men like the boys of Foxwarren fought and fell "For King and Empire."

The observer studies the list of names to discern the bare bones of the hidden stories they allude to. The first two soldiers remembered at Foxwarren bear the same surname: Baird. Who were E.A. and Robert Baird? What circumstances reduced them to two names on the war memorial of a Canadian Prairie village? With the indispensable assistance of Library and Archives Canada, we can unearth a few meagre answers.

It is no surprise to learn that they were brothers, the sons of Emily, Mrs. Garnet Baird of Foxwarren. Mrs. Baird's boys were Edmund and Robert. At the end of the line, the Baird boys were reduced to a string of letters on an out-of-the-way war memorial, but the routes that took them there were quite different.

In early 1915, Edmund Augustus James Baird was a twenty-year-old farmer, a native of Rochester, Kent, England. He was an early volunteer in the Canadian Expeditionary Force, enlisting in the Forty-Fifth Infantry Battalion in January 1915. Like so many other CEF battalions, the Forty-Fifth would not endure as a unit that proceeded intact to the Western Front: it was broken up and its members dispersed as reinforcements to front-line battalions.

By the late summer of 1916, Private Baird was attached to the Eighth Battalion, a storied unit, three of whose members would be awarded the Victoria Cross during the course of the war. In September 1916, the men of the Eighth Battalion found themselves at the Somme, fighting near the village of Courcelette.

It was there, close by Courcelette, that Emily Baird's first son was taken from her. Edmund's death register record provides these unsentimental details: "Previously reported Missing, now for official purposes presumed to have died." Private Baird remained Missing in Action. There is no grave a relative might have visited. Edmund is one of 11,285 Canadians killed in France remembered on the great Canadian monument to the missing at Vimy Ridge.

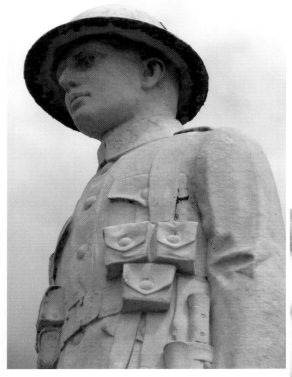

◄ Foxwarren, Manitoba

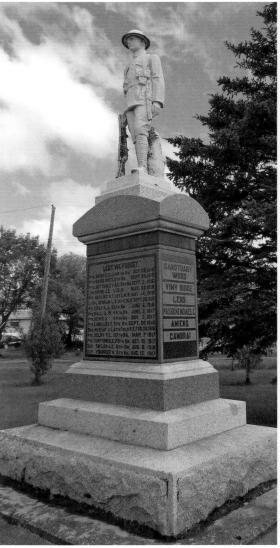

In contrast to his brother, Robert Baird did not volunteer for service in the CEF. Did he feel the sacrifice of one son had been enough for his mother to endure? We do not know. In any event, Robert was conscripted in late 1917 and went off to France, where his brother lay buried in an unmarked grave. He fought as Edmund had fought, whether he wanted to or not.

By late September 1918, a month and a half short of the November 11 Armistice, the conscript Robert was fighting beside his comrades in the Eighth Battalion, at Haynecourt near the city of Cambrai. On the last day of September, the war deprived Emily Baird of her second son. Robert's death register card is no more sentimental than his brother's: "Died of Wounds at No. 23 Casualty Clearing Station. During operations on September 29, this soldier was wounded in the stomach by an enemy bullet. His wounds were immediately dressed and he was evacuated to No. 23 Casualty Clearing Station where he succumbed to his wounds the following day."

In 1916, the population of Foxwarren, 207, was not much different from what it is today. Here is what is remarkable about Foxwarren and yet, at the same time, entirely typical of villages and small towns right across the country: that a community of just a couple of hundred should have fifteen of its sons make what we have come to call the "ultimate sacrifice," and that such a tiny population, moved by collective, unspeakable grief, would insist on investing the resources necessary to build such a grand, fine, worthy monument to the lost boys of Foxwarren.

It does not detract from the impact of the stone Foxwarren soldier that, to the discerning eye of someone well versed in the actual look of a Canadian soldier of the Great War, there is something not quite right—a uniform detail here, a battalion badge there. The reason behind the small anomalies is that the artisan who carved the white-stone soldier was someone who, in all likelihood, was utterly unfamiliar with an actual Canadian infantryman.

The Foxwarren soldier is carved in Carrara marble, a stone quarried for centuries on the northwestern Italian coast. Carrara marble was the medium of choice for the great Italian sculptors Donatello, Michelangelo, Bernini—the raw material they transformed into masterpieces: *St. George, David, The Rape of Proserpina.*

Close to half of two hundred or so Great War memorials featuring a soldier figure erected in Canadian communities in the decade after 1918 are of Carrara marble, carved by anonymous Italian craftsmen. Perhaps not one of them had ever been to Canada or seen a Canadian soldier of the Great War. Why would the people of Foxwarren and all the other Canadian communities with a white-stone soldier on their war memorials have looked to Italy for their commemorative monument figure?

The answer is simple economics: the Carrara monument operation was large-scale, and economies of scale were beneficial to purchasers. Italian product was less expensive than any of the alternatives. For a small community with limited resources, considerations of cost were significant. Out of the horrible losses of the Great War was born a business opportunity, and a flourishing industry bloomed in the 1920s to capitalize on it.

Not a single village or town anywhere in the country was left untouched by the catastrophe of the war. More than sixty thousand young Canadian men of the Canadian Expeditionary Force—and more than a few women—never returned from the battle-churned fields of Belgium and France. They lie in battlefield graves, many known, many not. As many as three times that number were casualties of war, wounded or otherwise damaged in body and mind by guns, bombs, and disease.

Across the country, communities sought to commemorate their lost sons and daughters, fathers and brothers and sisters—to ensure that their sacrifice would be honoured and never forgotten. Monuments to the lost burgeoned across the country. One of the preferred ways to honour the fallen was to erect a monument bearing the life-sized likeness in stone or in bronze of the good Canadian soldier. Entrepreneurial companies rose to the occasion, producing catalogues offering a range of likenesses, inviting communities to pick and choose.

About a hundred communities chose the option of a sculpture in Carrara marble. The expressive range of these Italian carvings is not broad: a soldier stands at attention or at ease, gazing into the distance. He is always in uniform, never bare-headed, invariably wearing cap or helmet, holding his rifle or resting on it. His calf leans against a blasted tree stump, or trench mortar, or piece of equipment.

31

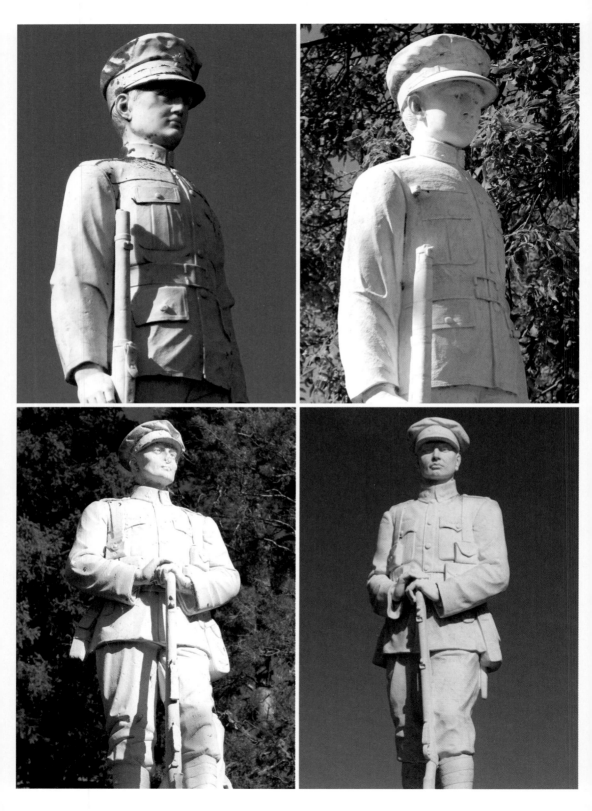

Community leaders in villages and small towns separated by thousands of kilometres frequently looked at the options on offer and made the same selection. Today at Canso, Nova Scotia, the standing-at-attention soldier gracing the community war memorial is the same as the one at faraway Oakbank, Manitoba. Looking closely, one sees that they are not perfectly identical; they were after all not stamped out on an assembly line but carved by individual artisans working to the same design.

The well-travelled visitor to Reston, Manitoba, may have a sense of déjà vu as he contemplates the village war memorial: it is the same design he saw the year before at Tatamagouche, Nova Scotia. He might well reflect that circumstance has been kinder at Tatamagouche than at Reston, where neglect has that community's stone soldier looking poorer by comparison to its Nova Scotia doppelgänger.

Just sixteen kilometres along Highway 16 from Foxwarren is Binscarth, Manitoba. Binscarth is a little more populous than Foxwarren, about 425 people in 2011, and boasts a museum that features a large collection of indigenous artifacts. Like its neighbour community, Binscarth has a war memorial featuring another stone soldier in Carrara marble, which lists the names of those of its citizens who fell in the Great War: nineteen names in this case, one of whom is a woman.

Margaret Lowe was a nursing sister doing her duty at the No. 1 General Hospital when, in May 1918, a fleet of German bombers targeted the military hospital at Etaples on the French coast. Among those killed in the bombing raid were three nurses, Binscarth's pride and joy Margaret Lowe being one of them.

33

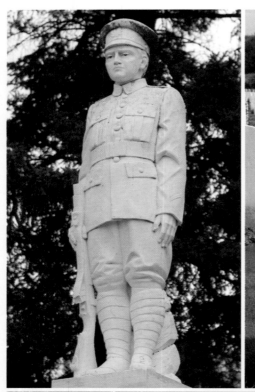
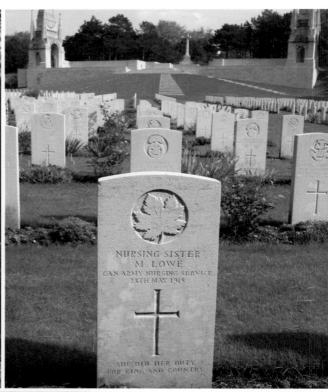

NURSING SISTER
M. LOWE
CAN. ARMY NURSING SERVICE
28TH MAY 1918

SHE DID HER DUTY
FOR KING AND COUNTRY

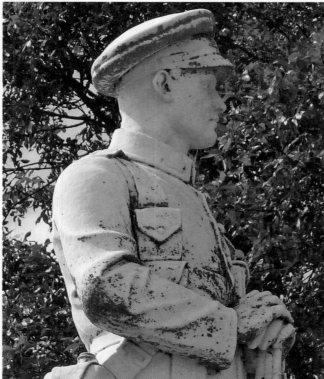
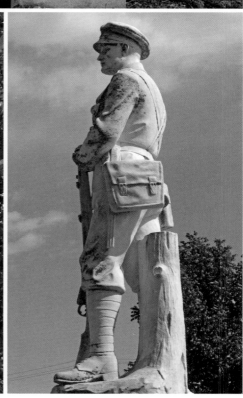

The stone soldier of Binscarth illustrates a fact about the marble figures carved for Canadian war monuments in the years after the Great War: not all of these figures reflect equal skill. The Binscarth figure looks "wooden," stiff, unnatural. Moreover, the verisimilitude of this figure is not as good as many other Italian marbles in Canada: the soldier's cap bears only a little resemblance to the one actually worn by a Canadian soldier—its visor is almost non-existent, its crown askew.

Holland, Manitoba, is some 260 kilometres southeast of Binscarth. Inquiry into the list of war dead at Holland undermines the notion that every name reflects a soldier killed in action in one or another of the Canadian Corps' iconic battles in the battlefields of Flanders and France. One of the names given on the Holland memorial is G. Lipsett.

George R. Lipsett enlisted in the 195th Battalion in June of 1917, claiming to be age eighteen. To the question "What is your trade or calling?" in his enlistment document, Lipsett gave the answer "School-boy."

Was young George motivated by the dreams of glory he would realize as a brave soldier on the Western Front? If so, he would have been just like all the other under-age boys who enlisted to do their heroic bit in the Canadian Expeditionary Force. Alas, George's dreams, whatever they may have been, turned to ashes. Scrawled across his enlistment form is this final handwritten note on George's military career: "Deceased TB." Young Lipsett never reached the battlefields of Flanders. The Commonwealth War Graves Commission lists him as having died 19 January 1918, his true age just seventeen. His is one of two war graves at Heward Cemetery in southeastern Saskatchewan.

The white-stone soldier honouring George Lipsett at Holland is a much better rendered facsimile of a Canadian infantryman than the

◀ OPPOSITE, CLOCKWISE FROM TOP LEFT ...
Binscarth, Manitoba

Margaret Lowe grave, Etaples British Cemetery, France

Holland, Manitoba

Holland, Manitoba

Binscarth figure. Compare the Holland figure to that at Binscarth and one readily sees it is "looser," less stilted, more natural-looking.

The Holland soldier's leg rests against a sawed-off tree stump, a typical feature of white-stone monuments. Why is that? Because marble is relatively brittle and easily broken; without being propped by such a feature, a marble soldier cannot be relied upon to stand securely on his own two feet.

Carrara marble is beautiful stone, but its beauty typically fades and erodes in the harsh Canadian climate. The Holland marble has withstood ninety Prairie winters in relatively good condition. It is not always so.

The Mohs scale measures mineral hardness on a 10-point spectrum, talc being 1, diamond 10. On the Mohs scale, marble is rated at just 3 to 4—relatively soft.

Returning to the white-stone soldier at Reston, one sees the frailty of Carrara marble. Much of the soldier's nose is gone, likely by human rather than natural intervention. Nooks and crevices have become home to various living creatures, which, if left to their own devices, over time may accelerate the already well-progressed deterioration of the Reston soldier. Carrara marble does not thrive on neglect; it demands care and attention. White-stone soldiers need to be looked after. Some communities attend vigilantly to the duty; others do not.

Rouleau, Saskatchewan, population about 450, is best known for having been the prime location for the popular 2004–2009 television sitcom *Corner Gas*. The village war memorial at Rouleau features a well-rendered soldier in Carrara marble. The white-stone figure is particularly intriguing—it still reveals quite vividly the character of the block of marble from which it was carved, a block not uniformly white but showing veins of varying, slightly darker colour.

Perhaps due to the inconsistent character of the stone, the Rouleau soldier has not weathered uniformly. Many facets of it are well preserved; others, particularly the soldier's face, have endured more poorly—a cavity in the corner of the left eye, a narrow line across the left cheek, defining a vein of more durable stone across the softer material on either side of it. Such are the vagaries of Carrara marble—no block was ever perfectly identical to the one quarried adjacent to it.

36

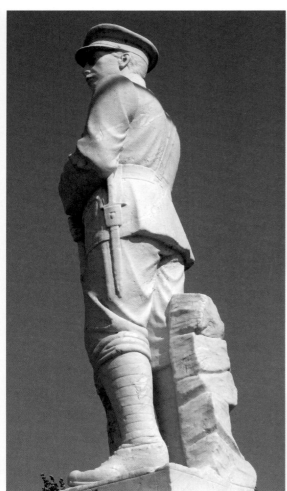

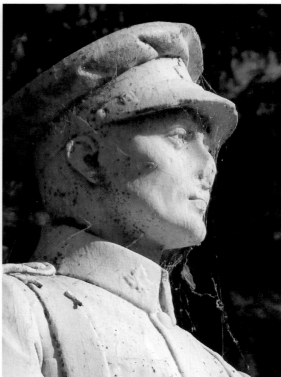

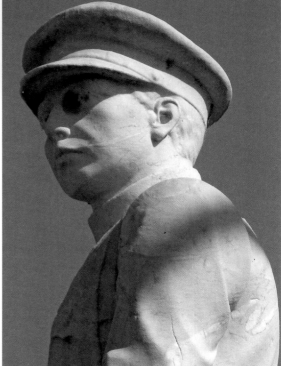

▲ *CLOCKWISE FROM TOP LEFT …*
Rouleau, Saskatchewan

Reston, Manitoba

Rouleau, Saskatchewan

One who studies the names of war dead listed on a community war memorial is sure to be drawn to one or more appearing among them. A name here or there arouses more than ordinary curiosity; it gives rise to the conviction that it has a story to tell, albeit one that may never be revealed.

There is such a name on the Rouleau monument, but decipher-ing that name, let alone the story behind it, is itself a small challenge. The names of the fallen of Rouleau are delivered in lead letters, a fea-ture not uncommon among our war memorials. As often happened elsewhere, some of the letters at Rouleau have fallen away over the years—or been intentionally removed. What is the name we deduce from these remnant letters: IMINITZ L?

With a bit of sleuthing, the monument detective learns the letters are meant to remember Lazar Diminyatz. At the time of his enlist-ment in mid-December 1915, Lazar was a seventeen-year-old farmer. He gave his next of kin as his father, living near Belgrade in Serbia.

A year and a half before Lazar's enlistment, it had been the assassi-nation of an Austrian archduke by a Serbian that sparked the outbreak of the Great War. Was it the subsequent ravishing of Serbia that incited young Lazar to join the Canadian Expeditionary Force in 1915? If so, Lazar never got the chance to exact revenge against his Austrian-German enemy.

Lazar Diminyatz died in May 1917, nowhere near the Western Front, let alone its Eastern counterpart on the other side of Europe. The young Serbian Canadian lies not in a battlefield grave but in a long-disused cemetery a few kilometres south of Rouleau. His is the only war grave in the overgrown Stanko Cemetery at Avonlea. The burial ground has just ten known graves, none more recent than 1948, each of them the last stop of a person with a Serbian name.

There is a story to relate about young Lazar. If only we knew it to tell.

The stone soldier on the war memorial at Taber, Alberta, is another in Carrara marble. In this case, there may be a legitimate claim that the likeness to a real Canadian soldier is truer than in most Italian white-stone soldiers—a tablet on the Taber monument claims that a local soldier, Thomas Love, posed for the photograph that the Italian carver portrayed in marble. The Taber tablet beams thus: "Master sculptors in Italy completed what is said to be one of the most perfect

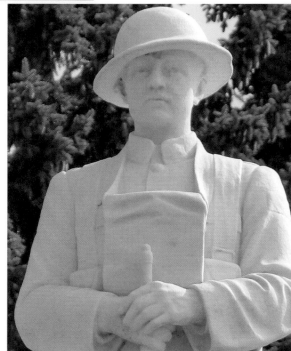

Taber, Alberta

replica [sic] of a Canadian soldier." Perfect or not, the Taber figure is certainly in the better half of the white-stone soldiers seen in Canada.

The Taber memorial exhibits in spades a fashion that was quite popular in the years immediately following the end of the 1914–1918 war. After the Allied victory over Germany, tons of war booty was gathered together and shipped across the Atlantic to our home and native land. The tonnage included 516 field guns, 304 trench mortars, 3,500 machine guns, and 44 aircraft.

It was not at all unusual that, in addition to a life-sized white-stone soldier, the good people of Taber agreed it would be a nice touch to have the memorial feature palpable evidence that Canada and the Empire had prevailed gloriously in the war against Germany. They arranged to have not one but three enemy guns—two Maxim machine guns and a field cannon—surround their white-stone soldier. The enemy guns remain there to this day.

A bronze tablet on the front face of the Taber memorial signals the community's gratitude: "To the glorious memory of the men of Taber district who died in the Great War." Twenty-five names appear on the list of the Taber fallen. The last of these is F. Whitcutt.

Born at Pelsall, Staffordshire, England, Frederick Charles Whitcutt was a thirty-four-year-old farmer when he enlisted in the Thirty-First Battalion in November 1914. A year later, the Thirty-First was in the thick of the trench warfare in Flanders not far from Ypres. The brief Thirty-First Battalion war diary entry for 15 November 1915 reports that sick parade had been held that day, with painful feet and myalgia being the leading complaints.

The diary entry records this final note: "1 man killed in Kemmel today." That man was Frederick Whitcutt of Taber. He is buried together with more than eleven hundred British soldiers, eighty of them Canadian, at Kemmel Chateau Military Cemetery, eight kilometres south of Ypres.

Cannington, Ontario, is a quiet, attractive town situated on the tranquil Beaver River. Cannington's charms are sufficient that Canadian novelist Timothy Findley chose to live there for a time. Local people take pride in Cannington having produced NHL all-star and two-time Stanley Cup winner Rick MacLeish.

In a lovely park in the river valley below Cannington's main street, the monument-seeker finds another war memorial with another white-stone soldier. The soldier stands smartly at attention facing west, a convenient configuration should the visitor arrive in late afternoon to study and photograph the monument.

At first glance, Cannington's white-stone soldier appears better preserved than many of its marble comrades, and it is. But on closer inspection in perfect afternoon sunlight, some of the troubles besetting these Italian-made figures are revealed. The soldier's right ear is slowly eroding away. Various creatures have set up housekeeping on the soldier's face: a group of insect galls in the corner of the right eye, more on the right eyelid. He wears a veil of spider silk. Further erosion is in store.

On reflection, one wonders whether these small frailties are unintentionally appropriate to the purpose of the Cannington monument: honouring those who were damaged and destroyed in the Great War. The memorial declares its duty: it is "Sacred to the memory" of the boys of Cannington who died from 1914 to 1918.

The list of the community fallen runs to just seven names. Two of the surnames are the same—Kift. As so often applies in such cases, the two Kifts are brothers: Private Horace O. Kift and Lieutenant William K. Kift, both sons of Elizabeth Jane Kift of Cannington.

Remarkably, William Kitchener Kift was still just seventeen when he was commissioned an officer in the 116th Battalion in July 1916. In his officer's declaration, he gave his profession as "Student."

The teenaged officer never attained majority. He died of wounds on 29 April 1917, by then having reached age eighteen. Lt. Kift's death record delivers another clinical account of a soldier's demise: "Died of Wounds. (Shrapnel wound multiple, Septicaemia following.) At Duchess of Westminster's Hospital, Le Touquet."

William Kift's final resting place is the huge—and beautiful—British military cemetery at Etaples on the French coast.

Horace Kift, aged twenty-three, enlisted in June 1915 in the Thirty-Seventh Infantry Battalion, but he did his fighting in the Nineteenth Battalion. Private Kith survived the war and returned to Cannington only to succumb to phthisis (tuberculosis) in early 1920. He lies under

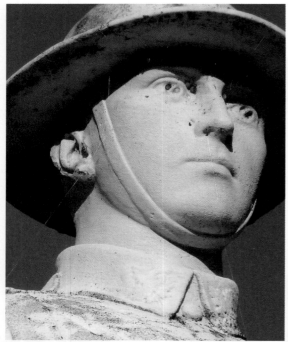

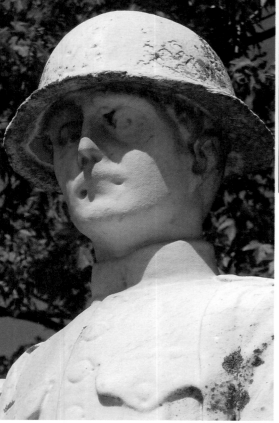

▲ CLOCKWISE FROM TOP LEFT ...
Cannington, Ontario

Cannington, Ontario

Colborne, Ontario

a Commonwealth War Graves Commission marker at Cannington Anglican Cemetery, just a short distance from the monument honouring his memory.

By comparison to the state of other white-stone soldiers, the marble figure at Cannington is beautifully well-preserved.

Colborne, Ontario, is the birthplace of a Victoria Cross recipient, Charles Smith Rutherford, VC, MC, MM. Captain Rutherford was awarded the VC for his actions at Monchy-le-Preux, France, in August 1918. In contrast to so many of Canada's Great War VC recipients, Rutherford's was not a posthumous award; he survived the action and the war, and lived to the great age of ninety-five.

The same sort of endurance cannot be attributed to the white-stone soldier on the cenotaph in Rutherford's hometown. The marble figure, particularly the face, has fared poorly in the nine decades or so it has endured extremes of summer heat and winter cold in downtown Colborne. The marble soldier is literally melting away, as if consumed by some dreadful flesh-eating disease. What will be left of it in another ninety years?

At lovely Wentworth Park in Sydney, Nova Scotia, there stands a monument erected by the Loyal Orange Lodge "to the memory of our brothers who died in World War One and Two." Sixty-one names are honoured on the pedestal panels. But the stone soldier standing at attention on the monument is another Carrara marble showing ravages similar to those at Colborne—the soldier's eyes are sunken, his nose half eroded away, his cap and collar badges similarly worn.

Worse still, consider the unhappy state of affairs at Thorndale, Ontario, where the results of natural weathering have been compounded by what is clearly the consequence of intentional vandalism. The brim of the soldier's helmet has been extensively chipped away, the mouth and nose both weathered by nature and damaged by human hand. Very nearly half of post–Great War memorial statuary in Canada is Carrara marble, and though only a minority of these figures show the extremes of abuse displayed at Thorndale, facsimiles of the Thorndale figure are not rare among Canada's white-stone soldiers.

A particularly unhappy case greets the visitor who goes out of her way to visit the Great War memorial at Hamiota, Manitoba.

43

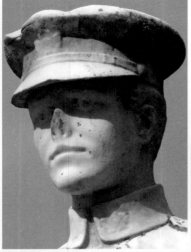

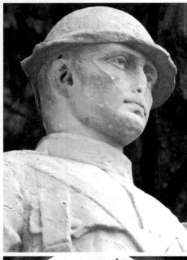

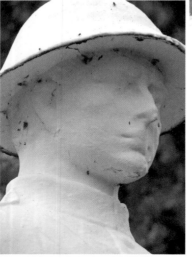

1914 **1919**

KILLED IN ACTION
St. JULIEN
1st Batt Sgt. E. J. ROWE. Apr. 23.1915 Aged 31
FESTUBERT
11th -- Cpl. R. C. BARNES. May 29.1915 -- 21
YPRES
2nd -- Pionr E. LAMBDEN. Mar.14.1916 -- 36
St. ELOI
34th -- Pte. A. H. DREW. Apr. 2.1916 -- 23
HILL 70
1st -- LCpl. H. A. LANNING. June 13.1916 -- 31
SOMME
37th -- Pte. H. LUCK. June 3.1916 -- 25
VIMY RIDGE
111th -- Cpl. A McDONALD. Apr.9.1917 -- 18
111th -- Pte. J. F. WARD. Apr. 11.1917 -- 52
FRESNOY
111th -- Pte. J. YARROW. Apr.30.1917 -- 28
111th -- LCpl. S. THOMAS. May 3.1917 -- 25
DROWNED
Smn.H.M.S.Niobe W. HAISELL. June 27.1917 -- 47

ERECTED BY
LODGE ROYAL OAK. No 26
SONS OF ENGLAND SOCIETY
AS A TRIBUTE
TO OUR FALLEN BRETHREN

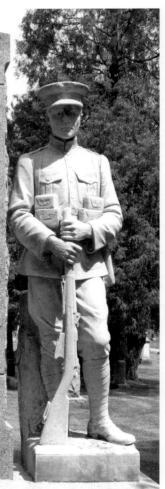

▲ CLOCKWISE FROM TOP LEFT ...
Sydney, Nova Scotia

Galt, Ontario

Hamiota, Manitoba

Thorndale, Ontario

About 850 people call Hamiota home. Hamiotans are good Canadians—they, too, take pride in their hockey heritage. They will tell you that a son of Hamiota, Dallas Smith, was the defence partner of the great Bobby Orr and twice won the Stanley Cup with Orr, as teammates on the big bad Boston Bruins of the 1970s.

Familiar phrasing appears on the front panel of the Hamiota war memorial pedestal: "Erected in honored memory of the men of the rural municipality and village of Hamiota who gave their lives and of all who served for King and Country during the Great War 1914–1918. Their name liveth for evermore."

How long is for evermore? The Hamiota monument was installed in 1922. More than ninety Manitoba winters have reduced the white-stone soldier of Hamiota to a much-eroded remnant of what the people of Hamiota beheld when they unveiled their proud monument in 1922. It was their intention and their expectation that their tribute would endure for evermore. What will remain of the marble soldier of Hamiota in the year 2122?

It is one thing to regret the natural ravages that time and climate have wrought on Canada's white-stone soldiers. It is quite another to recoil at the intentional harm by individuals having an entirely different attitude toward war memorials than prevailed in the hearts of those who, driven by grief, gratitude, and great reverence, built these memorials in the years after the war.

Consider the marble soldier gracing the cenotaph at Galt, Ontario. The fine memorial here differs from the norm in significant ways. The white-stone soldier stands beside the main pedestal, rather than on top. You can look him in the eye. The list of those killed in action meets the gold standard—it lists not just the names of the fallen, but their regiments, the battles in which they fought and died, and their ages at the point they fell.

The ages of the eleven men remembered on this excellent monument, erected by Lodge No. 26 of the Sons of England, range from eighteen to forty-seven; the piece is clearly a labour of love. Yet somehow, at some time in the past, someone unknown felt moved to alter this fine figure. Perhaps it was just a youth with a slingshot and a good aim, who gave his impulse scant consideration. In any event, the

handsome face of the Galt soldier now features a major cavity between the eyes. Today the stone soldier has the look of a man who has just this instant been shot by a deadeye enemy sniper. The alteration is not an improvement on the realized vision of Lodge No. 26, Sons of England.

In a similar vein, at nearby Kintore, Ontario, there stands on a cemetery hilltop a beautifully carved monument, again in Carrara marble. Here also an alteration has forever changed the impact of the fine rendering. Someone, perhaps the same youth with the same slingshot and the same disinclination to think before acting, has obliterated the Kintore soldier's left eye. In one sense, verisimilitude is served by the slingshot's effect, as many a handsome young soldier departed Canada with two functioning eyes, only to have one eliminated by a piece of enemy shrapnel.

Sometimes the consequence of vandalism is terminal. The stoneseeker goes into Pincher Creek, Alberta, expecting to find a figure in Carrara marble at the town cenotaph. Instead he discovers a modern stela—a polished granite slab—listing the names of the community's war dead. Commendably, some sixty names are honoured and the familiar invocation delivered—"At the going down of the sun and in the morning we will remember them"—but where is the stone soldier of Pincher Creek? Inquiry at the local Legion branch pays off: the Pincher Creek figure was a victim of vandalism so often that those responsible for looking after it grew weary and ultimately decided to remove it from harm's way. The Pincher Creek marble is still accessible, but one has to be content viewing it behind plexiglass in a dark corner of the Legion. Its impact on the observer wanting to see it in a prominent, public outdoor location is thus much reduced.

▶ *CLOCKWISE FROM TOP LEFT ...*
Pincher Creek, Alberta

Galt, Ontario

Thessalon, Ontario

Kintore, Ontario

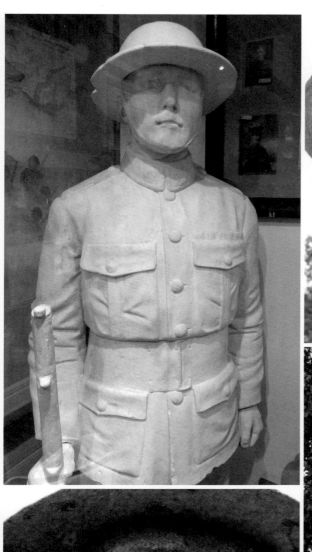
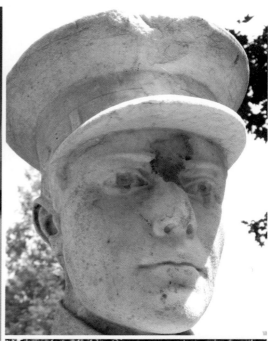
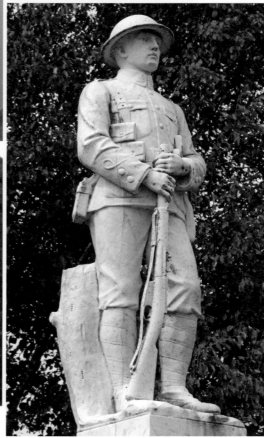
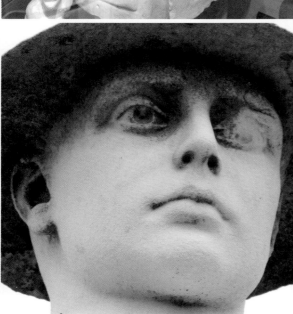

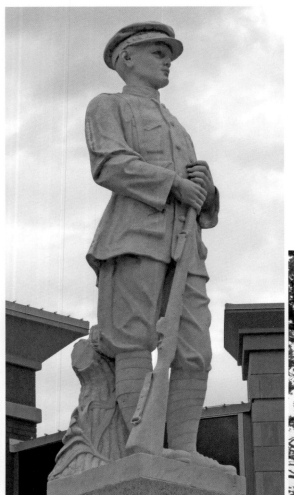

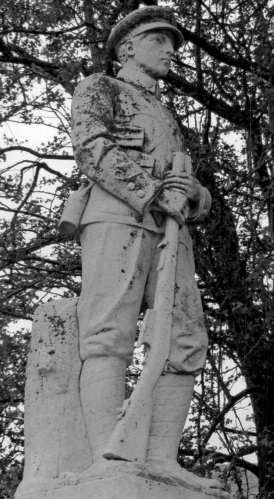

▲ *ABOVE* ... Lacombe, Alberta

▶ *RIGHT* ... Granton, Ontario

Yet there is good news among the bad. A gratifying number of Canada's war-memorial Carrara marbles are well-preserved, relatively unscathed, and just about as inspiring as they would have been nine long decades ago.

One such marble is to be found on the east side of the tranquil Thessalon River, which drains into the north shore of Lake Huron at Thessalon, Ontario. The town attracted a degree of notoriety in the early 1930s for having been briefly home to Angelina Napolitano, the first woman in Canadian history to rely on the battered-wife defence to justify the murder of her husband—a failed defence, as events unfolded. Nowadays the town impresses the visitor as being a quiet, non-violent sort of place.

The fourteen hundred people who live in Thessalon do not enjoy a particularly balmy climate. Average temperature in January is -10 C. Average annual rainfall exceeds eight hundred millimetres. With plenty of cold and precipitation, one could imagine that the white-stone soldier gracing the town's war memorial might have had a rough go these past nine decades. But it is not so.

The Carrara marble at Thessalon is one of the better-carved examples of the genre and, despite the climate extremes prevailing on the north shore of Lake Huron, it remains so to this day. Why has the soldier figure at Thessalon persevered so well while his comrades at Colborne, Thorndale, and Hamiota have slowly melted away? Did the carver who chose the block of Carrara marble he would transform into Thessalon's soldier have a more discerning eye for durable stone than that of his colleagues? Who can say?

The small city of Lacombe, Alberta, is home to more than twelve thousand people. One of its most celebrated sons is Roland Michener, Canada's twentieth Governor General and one of the country's most beloved. The prime minister who appointed Michener was Lester Pearson, a Liberal; Michener was a Tory, albeit a "red" one, but that was no impediment to Pearson making the appointment. The two men went back a long way: they attended Oxford University together, both shone academically, and on top of that were teammates and stars on the Oxford ice hockey team.

The white-stone soldier standing tall on the Lacombe war memorial is another Carrara marble, but one that is quite out of the

ordinary. Perhaps a devotee of the masterworks of the great Bernini, the unknown Lacombe carver produced a figure that is full of "flow": the folds in the soldier's trousers and sleeves, the flared tunic, the leafy branch on the obligatory tree stump supporting the soldier's leg—all of these are noteworthy. Among the hundred Italian marbles featured on Canadian monuments, there is no other figure quite like this. The fact that these characteristics do not make the soldier figure entirely resemble a Canadian soldier of the Great War is a mere quibble; the Lacombe figure is undeniably attractive even ninety years after its installation.

Situated a few kilometres north of Red Deer, Lacombe's climate is even harsher than Thessalon's, subject to greater extremes of cold and heat. Again, one wonders how it has come to pass that this particular marble has endured so well when figures even within a relatively short distance have not. A partial answer is that the Lacombe soldier has clearly been looked after. It is clean and free of lichen; it has not been left to look after itself. It has not been neglected.

At a tiny green space by a road junction at Granton, Ontario, stands a white-stone soldier at the other end of the spectrum: its attractiveness endures despite a crust of dirt and lichen the soldier wears like a shabby greatcoat. Granton sits about thirty kilometres north of London. In the 1920s it was its own community, and the Women's Institute of Granton cared enough to erect a fine monument to the memory of its fourteen "fallen heroes" of the Great War. Nowadays, Granton is but a memory; it has been swallowed up by amalgamation, a part of the Lucan Biddulph Township.

In 1924 neglect of the stone Granton soldier would have been utterly unimaginable. Today the big tourist draw in Biddulph Township is the "Black Donellys," a family of Irish immigrants who were ensnared in a local feud. In 1880 five of the Donellys were massacred, an event that became instant legend, one that continues to lure travellers to the area 135 years later.

Meanwhile, Granton's stone soldier closes in on invisibility, ignored by just about everyone except the monument-searcher who actively seeks it out. What is remarkable about Granton's marble soldier is that, despite the absence of caring attention, it perseveres. If a close observer

looks past the accumulated grime and lichen crust, she discerns a figure little eroded from the one that the Women's Institute would have proudly beheld on the long-ago day their monument was unveiled.

While Granton's status has diminished over the years since its monument was installed, some communities robust enough in the 1920s to have built a fine war memorial have almost disappeared. Ask Google to provide some background about Margaret, Manitoba, and one finds little more than this: Margaret is an unincorporated place on Manitoba Highway 843 between Dunrea and Minto.

Go to Margaret in person, and the seeker finds only a few houses and a scattering of farm buildings; no main street, no co-op, no card-lock, no cafe. But, with a little effort, one can find the community cemetery or, more aptly, the cemetery that grew when Margaret was a real, live community. There, behind an iron gate and a perimeter of trees, one sees at the back of the burial ground the white-stone soldier of Margaret.

Margaret the community may have largely vanished, but the community's war memorial not only endures but flourishes. The front panel of the red-granite pedestal bears the famous lines of John McCrae's poem "In Flanders Fields." On the pedestal's sides, bright new bronze tablets list the names of Margaret's fallen soldiers, just seven of them.

The Margaret marble is perfectly white and clean. The observer has no need to squint his eye through a crust of lichen and grime. A flagpole stands beside the monument, a fresh Canadian red maple leaf fluttering from its top. It is easy to imagine that despite the climatic extremes this figure has had to endure over the decades, it manages to look much as it must have the day the citizens of Margaret gathered to dedicate their memorial.

Who is to be credited for the excellent state of the white-stone soldier of Margaret? Nothing on the site offers an answer. Perhaps it is enough to rejoice that someone in a hamlet now largely vanished cares enough to meet a duty that almost all the people of Margaret would have faithfully embraced in the years following the Great War.

The town of Arcola in the southeast corner of Saskatchewan delivers a very different impression from nearly vanished Margaret

51

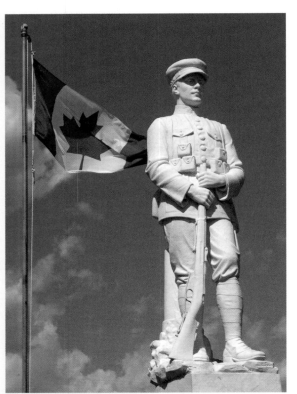

◄ Margaret, Manitoba

▶ *OPPOSITE* ... Granton, Ontario

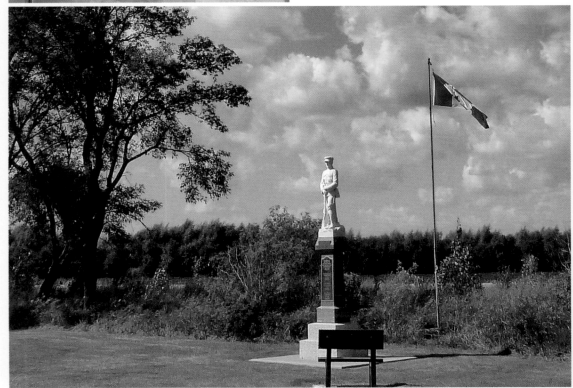

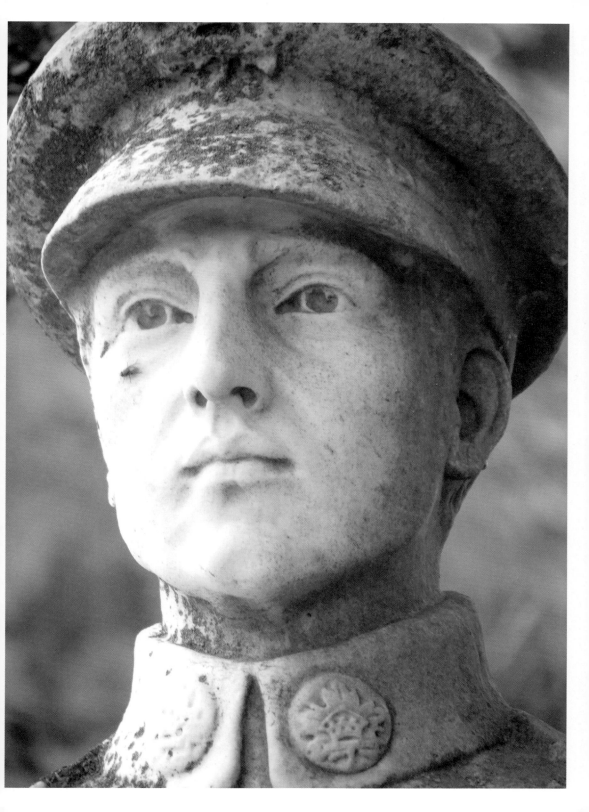

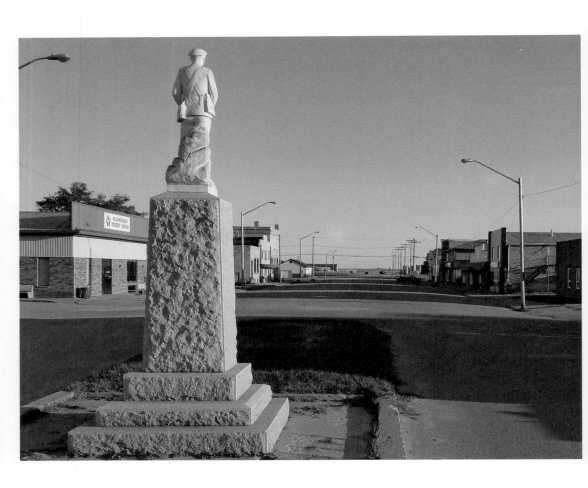

▲ *ABOVE AND OPPOSITE* ... Arcola, Saskatchewan

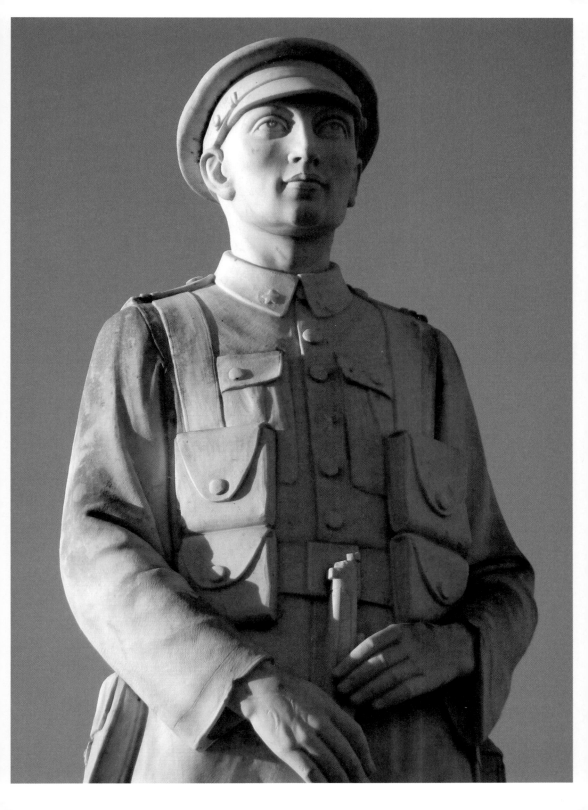

across the Manitoba line. Arcola's broad main street features a number of storefront businesses and several heritage-registered buildings: an opera house turned town hall, courthouse, land titles building, and others, some of which predate Saskatchewan's 1905 entry into Canadian Confederation. The community has thus acquired the moniker "Saskatchewan's Heritage Town," which was incentive enough to have induced Canadian filmmaker Allan King to shoot a 1977 feature film at Arcola based on W.O. Mitchell's classic *Who Has Seen the Wind*. About 650 people call Arcola home. Among Arcola's luminaries was another lauded Canadian novelist, Sinclair Ross, who found enough inspiration at Arcola to create his own celebrated Canadian classic, *As For Me and My House*, in 1941.

Standing on a grass median stripe down the centre of Main Street there is a very fine white-stone soldier, further demonstration of the talent of Italian carvers working in Carrara marble in the decade after the Great War. The young face depicted on Arcola's marble soldier conveys optimism, confidence, determination, and purpose—just the sort of attitude military recruiters were keen to cultivate among the youths they enlisted in the Canadian Expeditionary Force in the months following Canada's declaration of war in August 1914. It was also the sort of attitude the generals wanted Canadian lads to take into action the first time they clambered out of their trenches and went over the top to face enemy machine guns and artillery at the Western Front of Flanders and France.

The average January minimum daily temperature at Arcola is -21°C; the average July maximum 25°C. Michelangelo's *David*, carved in just the same medium as the soldier of Arcola—Carrara marble—has delighted and inspired admirers for five centuries. But *David* has had the great advantage of not having been exposed for decades to the extremes of Canadian weather. Few places strung out along Canada's forty-ninth parallel are subjected to greater variation of temperature and climate than alluring Arcola. After nearly a century stoically tolerating winter blizzard and summer furnace, the young soldier of Arcola shows virtually no negative consequences. He gazes as brightly over the Saskatchewan prairie as he did when first unveiled in 1926. Who can explain it? It is a wonder and a joy.

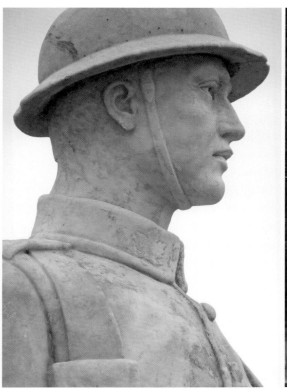

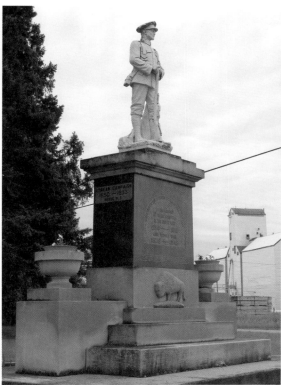

LEFT ... Roblin, Manitoba

RIGHT ... Gladstone, Manitoba

Roblin, Manitoba, was once called Goose Lake, but in 1904 it was renamed to honour Manitoba premier Rodmond Roblin. The community lies a short distance north of the fifty-first latitude, just inside the Saskatchewan border, and, like so many other Manitoba and Ontario hamlets, there is in a central area of town a Great War memorial upon which stands a white-stone soldier. Beneath the marble infantryman, on the granite pedestal's front panel, the passerby who cares to look will see these words: "Sacred to the memory of the men of Roblin and District to whose supreme sacrifice this memorial is dedicated." Below the dedication, familiar Belgian and French place names: Ypres, Somme, Vimy. On the side panels are listed the names of the thirty-nine sons of Roblin who went off to war, never to see Roblin again.

Canada's made-in-Italy memorial stone soldiers exhibit a limited range of attitudes: a uniformed man stands at attention or at ease, staring off into the distance. The nation's eight dozen or so white-stone soldiers reflect only a few individual designs. The monument-seeker who goes out of his way to find and study these figures recognizes a design he has seen before, then in a town farther along his way, he sees it again. This is not to say that any two white-stone soldiers are perfectly identical. Several may have been carved to the same design, but each was carved individually, so each is unique, even if only slightly. Some are more affecting than others.

Roblin's marble soldier is particularly distinctive and evocative: the young, handsome, strong-jawed soldier looks stalwart, resolute, imperturbable. It is easy to imagine that the throng gathered ninety years ago to unveil the town's monument to its lost sons was well pleased to behold the handiwork of their anonymous Carrara carver. Perhaps they would be gratified even now to see how well it still reflects on the intrepid young men of the district, despite the trials of ninety Manitoba winters and summers.

The war memorial at Gladstone, Manitoba, is as iconic a community monument to the Canadian fallen of the Great War as one is likely to find anywhere. Its Prairie context is writ large: a grain elevator close by in one direction, Branch 110 of the Royal Canadian Legion in another, a beautifully rendered bas-relief plains bison on the face of the monument pedestal.

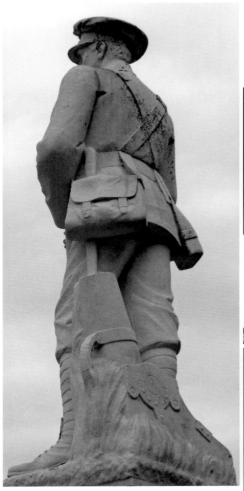

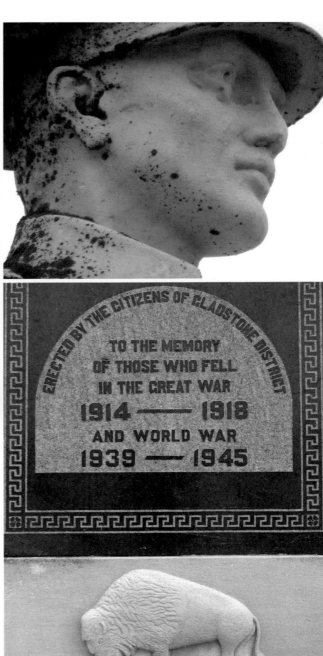

ERECTED BY THE CITIZENS OF GLADSTONE DISTRICT

TO THE MEMORY
OF THOSE WHO FELL
IN THE GREAT WAR
1914 —— 1918
AND WORLD WAR
1939 —— 1945

▲ Gladstone, Manitoba

Gladstone, Manitoba

Gladstone was the third name the Manitoba community adopted for itself. It was once "Third Crossing," then briefly "Palestine" before townsfolk settled on the name Gladstone in 1882, to honour the then British prime minister William Gladstone. This was not a rare honour for the highly regarded Liberal prime minister; a remarkable 330 soldiers in the Canadian Expeditionary Force bore the given name Gladstone. Indeed, sixteen CEF soldiers went through life with the Right Honourable man's full moniker: William Ewart Gladstone.

How many newborn boys in the Canada of 2005 or 2015 were named Anthony Charles Lynton Blair or David William Donald Cameron? If your guess is "absolutely none," you are probably right on the money. The Canada of 1885 was a very different entity from the current-day edition. In the late nineteenth century and in the early years of the twentieth, Canadians felt genuine affection, ardour, and admiration for the "Old Country," for Queen, or King, and Empire. That more than three hundred Canadian soldiers of the Great War had been named in honour of a British prime minister may seem scarcely comprehensible to modern sensibilities, but there was nothing at all strange about it in the 1880s and 1890s when the Union Jack fluttered from coast to coast and mothers across the country were giving birth to the future soldiers of the Canadian Expeditionary Force.

The white-stone soldier standing on top of the Gladstone memorial is in a familiar design seen in other Manitoba locations. It is neither as ravaged as the worst nor as well-preserved as the best of its doppelgänger comrades elsewhere in Manitoba. There is some erosion on the face and a serious accumulation of lichen on the north, back side of the figure. There are subtle differences too—rather than a tree stump, the left leg rests against a carefully detailed representation of a trench mortar.

At Gladstone the list of the community fallen runs to fifty-two names, a remarkable number for a hamlet of fewer than one thousand people. The names reflect the diverse demographics of the Prairies in the early years of the twentieth century: Broadfoot, Deihl, Demerais, Faraker, Hembroff, Huddlestone, McComb, Squair, Sylvester, Waller.

The list of Gladstone's war dead reveals an often overlooked fact of the Great War: it was not just men who faced the peril of enemy guns

61

and bombs. Fifty-one of the war memorial names are Gladstone sons; the fifty-second is that of nursing sister Agnes MacPherson.

Agnes MacPherson was twenty-five when she enlisted in the Canadian Army Medical Corps at Kingston in November 1916. Born at Brandon, she was living at Lakeland, twenty miles or so from Gladstone at the time. She listed her mother, Helen Mary MacPherson, as next of kin.

By May of 1918, Agnes was doing her duty at No. 3 Canadian Stationary Hospital, Doullens, France. She was working in the operating theatre at midnight, May 29, when German bombers made a direct hit. The enemy bombs killed twenty-five: two surgeons, four patients, sixteen orderlies and three nursing sisters, one of whom was Agnes MacPherson of Lakeland, Manitoba.

The death record is spare but graphic: "Died of Wounds. Was so severely wounded by enemy bombs dropped from hostile aircraft during a raid made on No. 3 Canadian Stationary Hospital, at Doullens, that she succumbed to the injuries sustained."

Nursing Sister Agnes MacPherson's war grave is one of 1,374 at Bagneux British Cemetery, about two kilometres southwest of Doullens. Forty-six graves are Canadian. Those in Plot III, Row A are all the consequence of the German bombs of May 30.

Contemplating the list of "Our Glorious Dead" on a community war memorial, how does a present-day observer begin to comprehend the cosmos of grief irretrievably concealed behind the relic names from a century ago? At Boissevain, Manitoba, another white-stone soldier stands at ease on top of a tall pedestal. The soldier is a little out of the ordinary. Instead of the usual tree stump, it is a jumble of broken rock and equipment he leans against. Though the head is somewhat encrusted in lichen and the face overrun by an array of occupying insects, the marble figure is in better condition than many of its Carrara marble comrades. The soldier stands at ease, looking a little distracted. His mind is elsewhere. Reasons for the soldier's distraction are easy to imagine.

The list of Boissevain's Great War dead runs to fifty-nine names. Three of these fifty-nine leap immediately to the eye. They are all Bowes: D. C. Bowes, J. L. Bowes, F. A. Bowes. If the loss of a single son was a catastrophe never to be overcome, how do we conceive of the

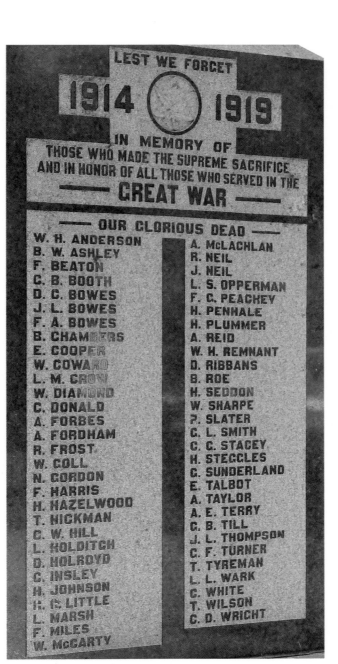

LEST WE FORGET

1914 1919

IN MEMORY OF
THOSE WHO MADE THE SUPREME SACRIFICE
AND IN HONOR OF ALL THOSE WHO SERVED IN THE
—— **GREAT WAR** ——

—— **OUR GLORIOUS DEAD** ——

W. H. ANDERSON
B. W. ASHLEY
F. BEATON
C. B. BOOTH
D. C. BOWES
J. L. BOWES
F. A. BOWES
B. CHAMBERS
E. COOPER
W. COWARD
L. M. CROW
W. DIAMOND
C. DONALD
A. FORBES
A. FORDHAM
R. FROST
W. GOLL
N. GORDON
F. HARRIS
H. HAZELWOOD
T. HICKMAN
C. W. HILL
L. HOLDITCH
D. HOLROYD
G. INSLEY
H. JOHNSON
R. G. LITTLE
L. MARSH
F. MILES
W. McGARTY

A. McLACHLAN
R. NEIL
J. NEIL
L. S. OPPERMAN
F. C. PEACHEY
H. PENHALE
H. PLUMMER
A. REID
W. H. REMNANT
D. RIBBANS
B. ROE
H. SEDDON
W. SHARPE
P. SLATER
G. L. SMITH
C. C. STACEY
H. STEGGLES
C. SUNDERLAND
E. TALBOT
A. TAYLOR
A. E. TERRY
C. B. TILL
J. L. THOMPSON
C. F. TURNER
T. TYREMAN
L. L. WARK
C. WHITE
T. WILSON
C. D. WRIGHT

▲ Cenotaph, Boissevain, Manitoba

impact of losing three? The Bowes boys are—or were—brothers: Donald Clifford, James Lawrence, and Frederick Arnold, the sons of Joseph and Margaret Bowes of Boissevain. The boys were twenty-two, twenty, and eighteen when the guns of August began to boom over the Western Front in the summer of 1914. By early January of 1916, all three of Joseph and Margaret's boys had enlisted in the Canadian Expeditionary Force. What vocational experience suited them to become men at arms? Donald was a grain buyer, James a banker, young Frederick a clerk.

By early 1917, the Bowes boys were all together, infantrymen in the Forty-Fourth Battalion. According to the Forty-Fourth war diary, February 27 was a humdrum sort of day: "Situation normal. Trench maintenance carried out during day. Completed opening up CHALK STREET and laying trench mats. Casualties during day 4 O.R. [Other Ranks] wounded. Weather fine."

A richer account of the day's events came from a different source:

> This is the saddest letter I will ever have to write and long before you get this letter you will have heard from the war office that poor Jimmie has passed away and Fred badly wounded and at present most likely on his way to England.
>
> They were both together with Eddie O'Neill and a McTaggart from Melita and all four were wounded together in the early hours of Feb. 28th. A rifle grenade dropped right among them but the boys were far the worst wounded . . .
>
> Oh mother, I am nearly heart-broken and crazy. We used to have such talks together and now I am left alone again. Jim passed away very quietly, thinking of us all and not of himself.
>
> Now Mother I will close this sad note for my heart is too full to write more at present.
>
> God make it more easy for you to stand this terrible blow . . .
>
> I will close your loving son,
> Cliff

According to his death register record, James Lawrence Bowes died of wounds in the field, 28 February 1917. He is buried at Villers Station Military Cemetery, about a mile northwest of Villers-au-Bois, France. By then, "Jimmie" Bowes had reached the age of twenty-three. "Fred" Bowes survived his brother by another eight days. His death record provides these spare details: "Died of wounds (Gunshot Wounds Legs, Face and Arms) at No. 6 Casualty Clearing Station." He was twenty-one. The middle brother is buried at Barlin Communal Cemetery Extension, about twelve kilometres from his brother.

And what of "Cliff" Bowes? He carried on alone, without his brothers, through the spring, summer, and early fall of 1917. What must it have been like for mother and father back in Boissevain, burdened with the loss of two sons, tormented by thoughts of the perils facing their third boy, still alive, still above ground somewhere in France?

By the autumn of 1917, the Forty-Fourth Battalion was back in Belgium in the thick of the fighting for the Flanders village of Passchendaele. On October 27, the battalion received an order to take Decline Copse. Zero hour was fixed for 10:00 p.m.; battalion positions were heavily shelled as men waited to go into action. Men of the Forty-Fourth jumped off at 2200 hours as planned and encountered heavy machine-gun fire, but by midnight the Forty-Fourth had taken Decline Copse. The following day, the Forty-Fourth successfully resisted an enemy counter-attack, but at the cost of eighty-six casualties. One of these eighty-six was Donald Clifford "Cliff" Bowes, killed in action. Back in Boissevain, Joseph and Margaret had lost their third son. The blow to the parents was aggravated by this: his brothers have marked, known graves; Cliff Bowes has none. He is one of nearly seven thousand Canadians killed in Belgium without a known grave who are remembered on the Menin Gate in Ypres.

It is the author's submission that the most evocative, affecting, and compelling of Canada's post-1914–1918 community war memorials are those—more than two hundred in number—that feature a life-sized representation in stone or bronze of a Canadian soldier of the Great War. Some of these monuments were rendered in bronze, some in granite, and many—close to half of the total—in Italian Carrara marble. A comprehensive, latter-day coast-to-coast survey of these monuments reveals much about their current state.

ABOVE AND OPPOSITE ... Boissevain, Manitoba

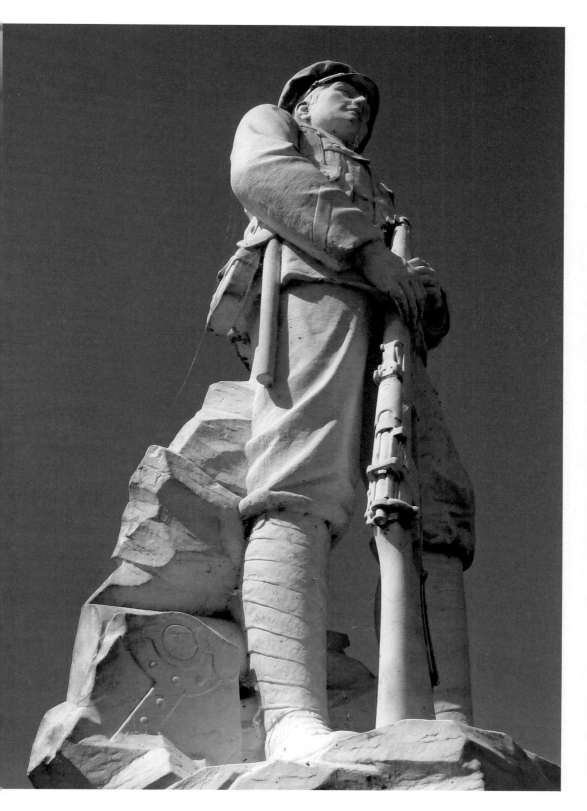

Nearly a century after the first stone tributes to Canada's fallen soldiers were erected, it is the Carrara marbles that leave the concerned observer feeling the widest range of emotions. Some, perhaps too few, retain much of the effect they inspired at the time of their unveiling in the years immediately after 1918. Given the excellent state of their preservation, we are still moved by the authenticity and conviction invested by the artist. We still feel impelled to honour the men we are meant to remember for evermore. Other, different emotions are inspired when the stone soldier has eroded in the unforgiving Canadian climate, or has been badly neglected by the same community that built it two and three generations ago, or—worst of all—when the stone soldier has been intentionally damaged and disfigured by individuals devoid of the reverence and gratitude that inspired the monument builders nine decades ago.

It is the Carrara marbles that induce the caring observer to wonder what will confront the monument-seeker of 2035 or 2055 or 2075. Fortunately, however fraught the future may look for the country's marble soldiers, the prospects are brighter for those rendered in more enduring media, a claim buttressed by appreciation of the handful of Canada's Italian-made monuments realized not in marble but in bronze.

Someone questing after monumental soldiers who ventures into Moosomin, Saskatchewan—was there ever a more quintessentially Canadian place name?—has a reward in store. Moosomin, population about 2,500 in 2011, lies just a few kilometres to the west of the Manitoba border. The town raised not one but two sons who would go on to distinguish themselves as Canadian national defence chiefs: Andrew McNaughton and Frederick Ralph Sharp. The soldier-innovator McNaughton was a major Canadian player who developed key advances in artillery science during the Great War.

At a little park close to the centre of Moosomin, one finds the town war memorial. A tablet near the memorial informs the visitor that the site was once the homestead of one Harry Mullin, Victoria Cross recipient. Mullin was awarded his VC for valour in the hideous morass of Passchendaele in October 1917. He lived to tell about it.

The Moosomin monument is capped by a soldier in the familiar at-ease pose of so many Carrara marbles, but this infantryman is not of

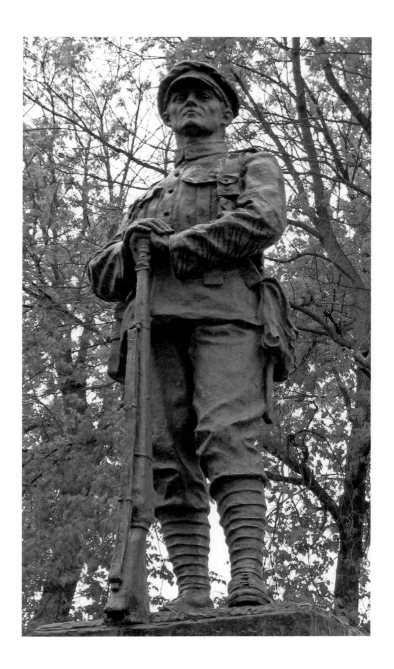

▲ Sergio Vatteroni; Moosomin, Saskatchewan

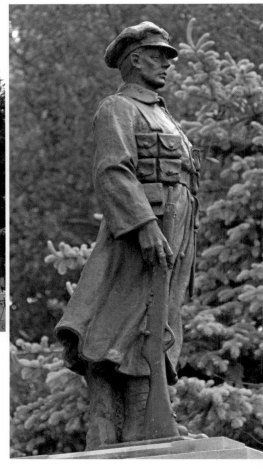

▲ Neepawa, Manitoba

white stone but bronze. And the artist who created the figure is not an anonymous stone-carver but a known Italian sculptor, Sergio Vatteroni.

Vatteroni was a Tuscan artist entirely familiar with Carrara marble, but the Moosomin movers and shakers wanted the best for the town's Great War fallen, sixty of whom are listed on the monument pedestal. The best was not marble but bronze. Vatteroni's figure was cast at a Firenze foundry, shipped across the Atlantic, then delivered by train to Moosomin, where it was dedicated in 1924.

Vatteroni gets no marks for originality; his Moosomin design is essentially the same as the white-stone soldiers we have already seen— at Reston, Holland, Hamiota, Roblin, and Margaret—and many other Carrara iterations across the country. The big difference is that while too many of the Moosomin's marble siblings are in sorry condition, Vatteroni's figure is entirely whole: as bright, crisp, and sharply defined as it was in 1924. Such is the difference between marble and bronze.

Neepawa, Manitoba, population about 3,600, is best known as the hometown of celebrated Canadian writer Margaret Laurence, creator of cherished Canadian classics *The Stone Angel, A Jest of God, The Diviners,* and others. A short walk from Laurence's house delivers the pedestrian to the Neepawa town hall and the town's fine war memorial. The front of the pedestal lists the "memorable battles" in which Canadians fought and died; side panels give the long list of names of sons of Neepawa and Plains County who died in those battles and lie in foreign graves known and unknown.

Standing on top of the pedestal is another bronze soldier. It is the work of an Italian sculptor whose name regrettably seems to have been lost. The sculptor's Canadian "Tommy" warrants higher marks for originality than its compatriot at Moosomin. Dressed for colder weather in his winter greatcoat, the soldier stands at attention, looking taciturn and serious. There is no levity in his expression. Why should there be? One imagines the soldier standing on parade, attending to instructions from his battalion commander about the battle he is soon to enter. In such circumstances—about to go into action against enemy machine guns—it is easy to imagine a soldier felt anything but lighthearted.

On Remembrance Day in 1922, a throng of some seven thousand people gathered at New Westminster, British Columbia, at a height of

land overlooking the Fraser River. They were there to dedicate the city's new war memorial. The project, initiated by the Board of Trade, had been widely and generously supported throughout the community. The collaborative endeavour culminated in a fine and unusual bronze—a wounded soldier, wearing a head bandage and no helmet, looks over his left shoulder at something of interest on the horizon. He holds his rifle, bayonet mounted. He is expectant, vigilant, ready for action.

Two names appear at the rear of the figure's base: George Paterson and A. Fabri. Major Paterson was a soldier, a veteran of the Great War, Fabri an Italian sculptor. Paterson designed the figure; Fabri produced it. Shortly after the dedication, a captioned photograph of the event was published in *Saturday Night* magazine. The picture conveys better than a thousand words how significant the occasion was to the people of New Westminster; a group of dignitaries, surrounded by some of the crowd, are gathered around the monument. "Mayor J.J. Johnson," *Saturday Night* reported, "represented the City Council at the impressive service, attended by thousands of persons from New Westminster, Greater Vancouver and the Fraser Valley. Brigadier-General Victor Odlum, C.B., C.M.G., D.S.O., officiated."

At the time, in the early 1920s, *Saturday Night* frequently featured such reports. Such gatherings were not unusual but routine in a country just a few years removed from the horror of the Great War.

The figure wears the green patina typical of bronzes exposed to the elements for an extended time, a patina that only enhances its effect. Because it is bronze rather than marble, the head-bandaged soldier of New Westminster retains all of its 1922 physical integrity—it is as vivid, evocative, and impressive as it was on the occasion of its unveiling.

One final Italian work merits our attention. Some 5,900 kilometres east of New Westminster, on the Nova Scotia side of the Isthmus of Chignecto, sits the town of Amherst, established by Yorkshiremen in 1764 following the cruel expulsion of the Acadians by British authorities.

Amherst's progeny include two Nova Scotia premiers, Canada's sixth prime minister, Sir Charles Tupper, the celebrated Canadian painter Alex Colville—all of them long gone to their reward—and one luminary who is still very much alive, singer-songwriter Leslie Feist.

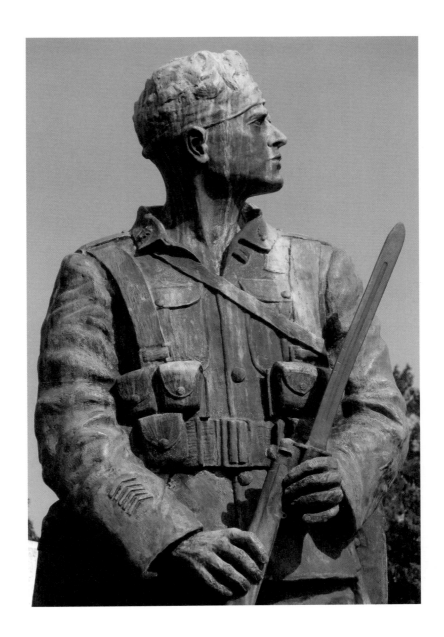

▲ A. Fabri; New Westminster, British Columbia

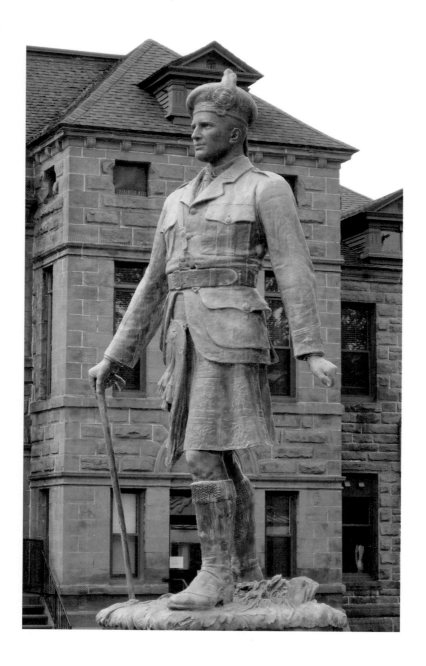

▲ A.G. Ghiloni; Amherst, Nova Scotia

During the Great War, Amherst was the site of a prisoner-of-war camp whose clientele included the Russian revolutionary Leon Trotsky.

Another wartime event led directly to the creation of Amherst's remarkable war memorial. In October 1915, Captain Leon Hall Curry was killed in action, a casualty of enemy mortar fire, whilst fighting with his comrades in the Forty-Second Battalion, Royal Highlanders of Canada. He was two days short of his twenty-ninth birthday.

Like the multitude of other bereaved Canadian mothers and fathers, Curry's parents were devastated by the loss of their son, but, in contrast to the great majority of others, the Currys had the means to honour their lost son in a unique way—they commissioned an Italian sculptor, A.G. Ghiloni, to create a life-sized effigy of their boy, in bronze. The sculptor achieved what was said to have been a remarkable likeness. Ghiloni's figure does not rely on the conventions of the Carrara marbles we have seen throughout this chapter. Wearing his highland kilt and beret, walking stick in right hand, the expressive figure radiates confidence, optimism, personality.

The monument was installed in a central downtown location in Amherst, July 1921. Ghiloni's sculpture was intended—and quickly embraced—as a tribute to not just Curry but all the young men of Cumberland County who went off to war and never returned from the battlefields of France and Belgium. A dozen panels list the names of the fallen. A tablet on the front of the monument, below Ghiloni's figure, bears these words: "Erected by Senator and Mrs. Curry in memory of their son Captain Leon Hall Curry and his brothers in arms from Cumberland County who gave their lives to their country in the Great German War 1914–1918."

Italian artisanship looms large in Canadian war memorials of the Great War—not just that of Vatteroni, Fabri, and Ghiloni, but also the unknown Tuscan stone-carvers who transformed blocks of Carrara marble into likenesses of Canadian soldiers into which mothers and fathers, sisters and brothers, daughters and sons poured their heartbreak and gratitude, their grief and reverence. The traveller who takes the trouble to look will find that while some of the Italian legacy has faded over the decades, much remains to admire. ✥

75

III

AMERICAN AND
BRITISH CONTRIBUTIONS

IS THERE A CITY STREET junction anywhere in Canada better known than Portage and Main in downtown Winnipeg? One would be hard-pressed to debate the claim. At the southeast corner of the iconic intersection is the imposing edifice of the Bank of Montreal. Here, standing on a finely wrought pedestal, there is a bronze soldier every bit as imposing as the grand building towering behind it.

The soldier is the work of James Earle Fraser (1876–1953), a renowned American sculptor whose work includes famous public statues of equally famous Americans: Benjamin Franklin, Thomas Jefferson, Abraham Lincoln among them. Fraser is also the artist responsible for the design of the 1913–1938 American buffalo five-cent coin cherished by coin collectors all over the continent.

The bank commissioned Fraser to create a monument honouring its employees who answered the call of duty to "King and Empire"

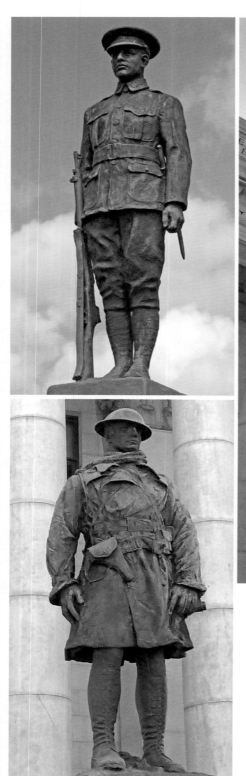

during the Great War and made the supreme sacrifice in the battle-fields of Flanders and France. The finely rendered front panel of the pedestal bears these words: "Patria. To our men who fell in the Great War 1914–1919." Some fourteen hundred bank employees answered the call; of these, 230 never returned to their bank stations but lie buried in battlefield graves both known and not.

Fraser's model for the Winnipeg bronze was a bank employee who did return from the Western Front. Captain Wynn Bagnall enlisted as an artilleryman in the first month of the war, September 1914. He distinguished himself as a soldier and was awarded a Military Cross for gallantry before returning to the bank for a period of time after the 1918 Armistice.

Fraser's warrior wears a holstered pistol at his waist and holds a binocular in his left hand. His look conveys steely resolve. The Winnipeg figure is an admirable reflection of precisely the brave, stalwart qualities the Bank of Montreal wished to attribute to its men of arms, the virtues for which the bank sought to have its lost men remembered and honoured.

The artist said of his Winnipeg monument, "Here is no giant warrior god on a high pedestal, but a man. He is tough, ready for the fight, his feet apart, arms held loosely by his sides ready. His helmet is just slightly at an angle, and, under its brim, his face reflects strength and determination."

The Portage and Main soldier is all that and more. With his double-breasted coat, his high laced boots, the jaunty angle of his helmet, Fraser's soldier is more American than he is Canadian. He has the look of an officer of the American Expeditionary Force rather than his Canadian counterpart. He shows no marks or insignia suggesting that he is Canadian. But this hasn't diminished the impact of Fraser's Winnipeg warrior: dedicated in December 1923, it has inspired memory and reverence for lost Canadian soldiers in all the years it has stood at that most Canadian of intersections.

Canada has far fewer post-war memorial soldier figures of American and British origin than it does Italian sculptures of Carrara marble, but those we do have tend to be highly worthy, and because almost all of them are bronze, they are in a much better state of preservation than many of the Italian marbles surveyed in the previous chapter.

Middle Musquodoboit is a Nova Scotia farming community of fewer than seven hundred people. At the village war memorial, the polished granite pedestal lists the community's war dead by the famous battles in which they fought and died: three at the Somme, three more at Vimy Ridge, four at Passchendaele, two at Arras, one at Cambrai. Thirteen in all. The front panel bears these words: "1914–1918. Erected by the citizens of District No 21 Musquodoboit in loving memory of their noble sons who gave their lives in the cause of liberty and justice."

Dozens of communities elsewhere in the country chose to commemorate their noble sons by way of a worthy Italian marble. Here at Middle Musquodoboit, the bereaved citizenry went one step further—they chose a monument in bronze. At the soldier's base, the sculptor is identified as J. Paulding. The foundry is named, too: the American Art Bronze Foundry of Chicago.

John Paulding (1883–1935) was, with E. M. Viquesney, one of the two most prolific American war memorial sculptors in the years following the Great War. Two of Paulding's designs, *American Doughboy* and *Over the Top*, were realized on dozens of US war memorials. Because they are rendered in bronze, Paulding's monuments have endured superbly.

The sculptor's standing-at-attention soldier in Middle Musquodoboit is not as dynamic as Paulding's famed American figures, but it remains a shining example of the durability of bronze: it looks as grand as it ever did.

That such a small community should invest the substantial resources necessary to have its lost soldiers commemorated through a bronze produced by a major American sculptor underscores the great significance invested in war memory in the 1920s, significance scarcely imaginable today.

Eighty kilometres northwest of Middle Musquodoboit, at Great Village, another bronze soldier stands at attention on another polished granite pedestal. A tablet on the pedestal front lists eighteen names—"The boys who gave their lives in the Great War"—one of whom, Corporal Clyde Patriquin of the Twenty-Fifth Infantry Battalion, had distinguished himself by earning not one but two gallantry awards, the Distinguished Conduct Medal and Military Medal, before he died of wounds suffered in an enemy artillery barrage in June 1918. Patriquin was twenty-three at the time of his demise.

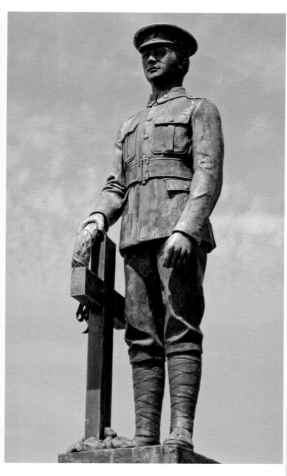

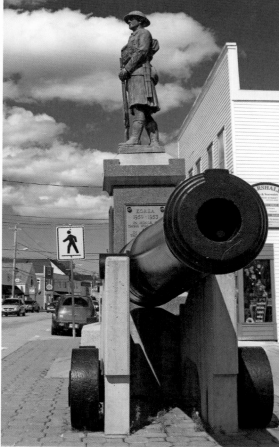

▲ *ABOVE* ... Great Village, Nova Scotia

▶ *RIGHT* ... Digby, Nova Scotia

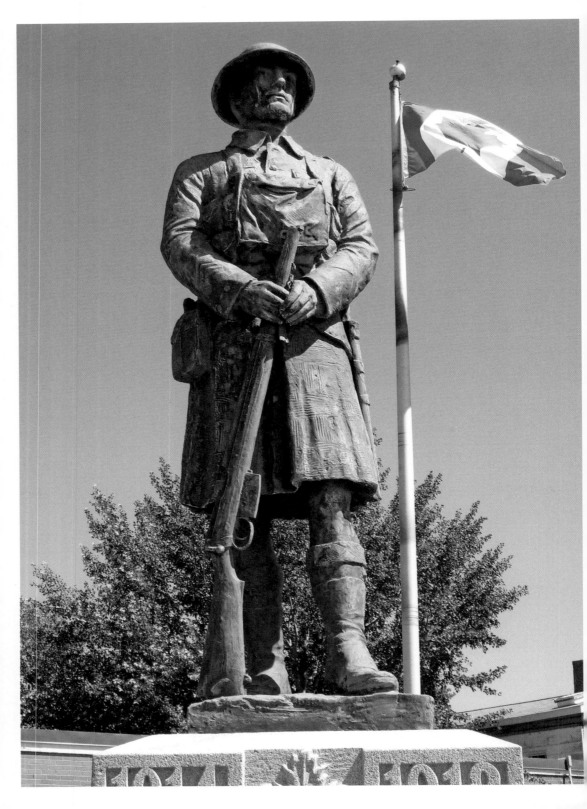

The Great Village bronze is a departure from Middle Musquodoboit —the soldier stands at the battlefield grave of a comrade. He holds a wreath in his right hand. Regrettably, the bronze reveals nothing to identify either the sculptor or the foundry in which it was cast, but it is almost certainly an American piece from about the same time as Paulding's Musquodoboit bronze.

Nova Scotia proudly raised four highland battalions during the Great War—an entire brigade—and the province's highlander heritage is well represented among the province's war memorials.

Pugwash, a fishing and salt-mining community on Nova Scotia's Northumberland shore, was the birthplace of banker-philanthropist Cyrus Eaton. For years Eaton hosted the Pugwash Conference on Science and World Affairs, whose Cold War–era aim was to promote disarmament and reduce the peril of nuclear annihilation.

In a small green space in the centre of town, a bronze soldier in highlander kit stands on a pedestal bearing a bas-relief Scottish thistle and three panels of names. No sculptor's mark appears on the base, but the foundry is identified: T.F. McGann and Sons of Boston.

A visitor to the Pugwash monument finds her eye drawn to two names among the thirty-two Pugwash war dead: brothers Harold Esty Benjamin and Percy Earl Benjamin. Each was killed in action while serving in the Fifth Canadian Mounted Rifles—Harold at Ypres in June 1916, Percy at Passchendaele in late October 1917. Neither brother has a known grave. Each is remembered on the Menin Gate at Ypres, the great monument to the 55,000 British and Commonwealth soldiers who died in Flanders and who have no known grave. Even if he had the resources to travel to the battlefields where his sons died, their widower father could never see their graves. In that light, it is easy to imagine the significance the Pugwash memorial likely held for him.

◄ OPPOSITE ... Pugwash, Nova Scotia

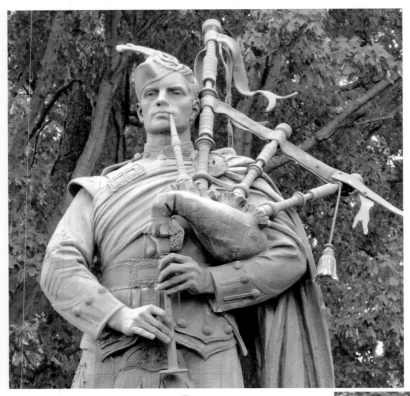

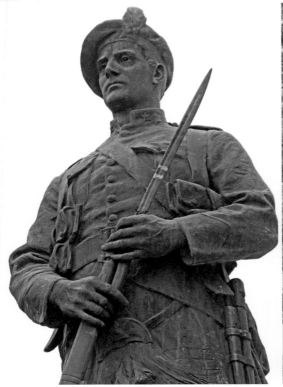

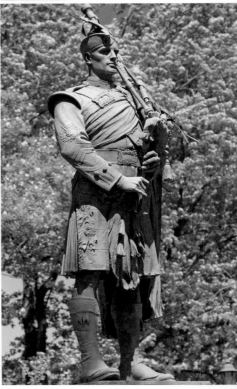

Digby, Nova Scotia, sits near the mouth of the Bay of Fundy, the home port of a fishing fleet that supplies scallops to aficionados who consider the bivalve second to none among seafood delights. Digby luminaries include Charles Marvin "Pop" Smith, a pioneer major league baseball player of the 1880s, an era when big-league clubs included the likes of the Columbus Buckeyes, Louisville Eclipse, and Worcester Ruby Legs.

At a prominent location on Digby's waterfront main street, another bronze highlander stands vigil. It, too, is an American bronze, cast by the Architectural Bronze Company, whose sculptor is unknown. Seventeen names are listed on the memorial panel, the first of which is Lieutenant Charles Dayrell Shreve, MC, a law student at the time of his enlistment in January 1916. His Military Cross citation illuminates the particulars of the soldier's gallantry: "For conspicuous gallantry and devotion to duty. While the battery was firing a barrage it was heavily shelled, and two ammunition dumps were set on fire. He kept all his guns in action, and himself threw buckets of water on the burning ammunition, besides assisting the wounded and going from gun to gun to steady the men."

Six months after the MC award, Lt. Shreve was in the thick of the fighting for the city of Cambrai when, on 7 October 1918, with just five weeks to go before the November 11 Armistice, he was killed in action while serving in the Ninth Brigade, Canadian Field Artillery. The Digby lad is buried in the beautiful military cemetery at Bourlon Wood. He lies among 220 Canadian comrades, almost all of them killed in the same battle.

In two other Nova Scotia communities, Remembrance Day ceremonies unfold before a bronze soldier in highlander kit. The visitor

travels to Chester and New Glasgow to see them, and he is well rewarded for his effort. Both pieces are the work of Scottish-born American sculptor, John Massey Rhind (1860–1936), creator of an array of US public monuments to famous Americans: William Tecumseh Sherman, Ulysses S. Grant, Henry Hudson, and George Washington among them. Massey Rhind was an American who loved Nova Scotia and who was inclined to spend his summers in Canada's ocean playground. The tradition continues—there are many such Americans to this day, ones having a principal home in the US and a summer one somewhere close to the Nova Scotia coast.

Massey Rhind's summer Shangri-La was at Chester; he grew so found of the town and its coastal surrounds that he decided to design, produce, and donate a war monument to the community, a bronze he called *The Highlander*. The figure, said at the time to be valued at $6,500, was unveiled on its pedestal in the summer of 1922. The base and steps are of granite and were donated by the village. The sculptor's model was a local Great War veteran. Reporting on the monument dedication, the Halifax *Chronicle Herald* described Rhind's figure as "stern, watchful, full of reserved energy, ready, if need be, to offer himself as a sacrifice in defense of all he holds dear."

A tablet on the monument pedestal lists the names of fifty-three "boys who fought and fell" in the 1914–1918 war, boys from Chester and nearby New Ross, Blandford, Mill Cove, Chester Basin, and Gold River.

Massey Rhind's Chester bronze is a very fine work; his bronze highlander at New Glasgow, two hundred kilometres northeast, is even better. Indeed, it is one of the finest community war memorial figures in all of Canada. A piper inspires his comrades as the battalion prepares to go into battle. He exudes manly, fearless, heroic strength. Every detail of the piper's kit—bagpipes, cap, sporran, and kilt—are richly, unsparingly portrayed.

A highland piper is a most suitable emblem for a war memorial in this part of the country. New Glasgow is just a short distance from Pictou, where in 1773 the ship *Hector* delivered the first Highland Scot settlers to New Scotland.

Below the brave piper monument at New Glasgow, two bronze panels list the names of the community's Great War fallen, many of the

◄ LEFT ... Bernard Partridge, "Canada!" *Punch* magazine, 1915

► RIGHT ... Joseph Whitehead; Liverpool, Nova Scotia

names shared with immigrants who arrived on the *Hector*—Cameron, Campbell, Fraser, McKay, Murray, Ross. Not every name is that of a New Glasgow son. The first two listed are women—nursing sisters who paid the ultimate price for having done their duty as battlefield nurses.

Isabel Katherine Cumming was the daughter of the Reverend Robert Cumming of New Glasgow. Nursing Sister Cumming enlisted in May 1915 at London, England. She survived the war, but after being repatriated to Canada, she died at age forty-one, likely a victim of disease, in early 1921. She is buried in a Commonwealth war grave, not far from the New Glasgow monument, at Westville's Auburn Cemetery.

The second nurse, Margaret Marjory Fraser, enlisted very early in the war, September 1914. In June of 1918, by then promoted to nursing matron, Fraser, thirty-four, was serving on the hospital ship HMHS *Llandovery Castle* when, on June 27, the ship was torpedoed and sunk by German submarine U-86. Some 234 nurses, physicians, and patients were killed in the attack. One of the casualties was Margaret Fraser.

Margaret's father, Duncan C. Fraser, had been Nova Scotia's Lieutenant-Governor from 1906 to 1910. His daughter's final resting place at the bottom of the Atlantic of course has no marker. There is no cemetery the father or other family members could have visited to pay their respects and focus their grief. Fraser is remembered on the monument to those lost at sea, the Halifax Memorial, located at the southern extremity of Point Pleasant Park, facing the broad Atlantic. And, of course, she is remembered prominently on the remarkable piper monument at New Glasgow, a monument that surely became a magnet for those of her kith and kin who wished to remember and honour her in the years after U-86 fired its lethal torpedo at the *Llandovery Castle*.

In the spring of 1915, an illustration in the British magazine *Punch* drew popular attention to the first great success of the Canadian Corps' First Division, at the Second Battle of Ypres in April of that year. In the wake of Germany's first use of poison gas as a weapon of war, it was the Canadians—at St. Julien and Kitchener's Wood—who reversed initial enemy advances and eventually prevailed over the German army. The illustration, by Bernard Partridge, depicted a jubilant Canadian soldier, British and Canadian flags in his left hand, rifle in his right, his cap raised high at the tip of his bayonet.

The image, titled "Canada!", was the seed of a groundswell that would eventually result in the Canadians being widely regarded as the best British fighting formation on the Western Front, the "shock troops" of the British Army.

No one knew it in 1915, but within a few years of the 1918 Armistice, the Partridge illustration would inspire several war memorial sculptors and culminate in an array of monuments that echo the Partridge cartoon.

One such exultant monument is to be found at Liverpool, Nova Scotia. His right hand holding helmet aloft, the left grasping his Lee-Enfield rifle, feet straddling battlefield debris, the bronze soldier of Liverpool is a study in the joy and relief of victory. He has come through the fire of battle—alive and victorious—and he is euphoric.

The Liverpool figure is the work of British sculptor Joseph Whitehead (1868–1951). Iterations of the same work grace British cenotaphs too, at Stafford in the West Midlands and Truro in Cornwall. Apart from his war memorials, Whitehead is well regarded for a range of far-removed public monuments, from his *Titanic* Engineers monument at Southampton, to his bronze tribute to Father Damien at Molokai, Hawaii, to his effigy of Charles Kingsley, historian, novelist and close friend of Charles Darwin, at Bideford, Devon.

On the face of the Liverpool pedestal, there is a handsome bronze tablet featuring a bas-relief maple leaf and beaver. The panel lists the names of forty Liverpool lads who died in the war of 1914–1918. Here, too, brothers are remembered, lamented and honoured. Stanley and Lawrence Annis, sons of Herbert and Clara Annis of Caledonia, Queens County, were aged twenty-two and twenty when they answered the call—young Lawrence in May 1915, older brother Stanley ten months later in March 1916.

After enlisting at Montreal with the Forty-Second Battalion, Royal Highlanders of Canada, in the spring of 1915, Lawrence Annis had by the late summer of the following year marched with the battalion from Ypres to the River Somme in northern France. The opening volleys in the Battle of Courcelette began 15 September 1916 and went on for a week. Lawrence would die within the first hours, his death register card indicating simply "Killed in Action." His body was not recovered

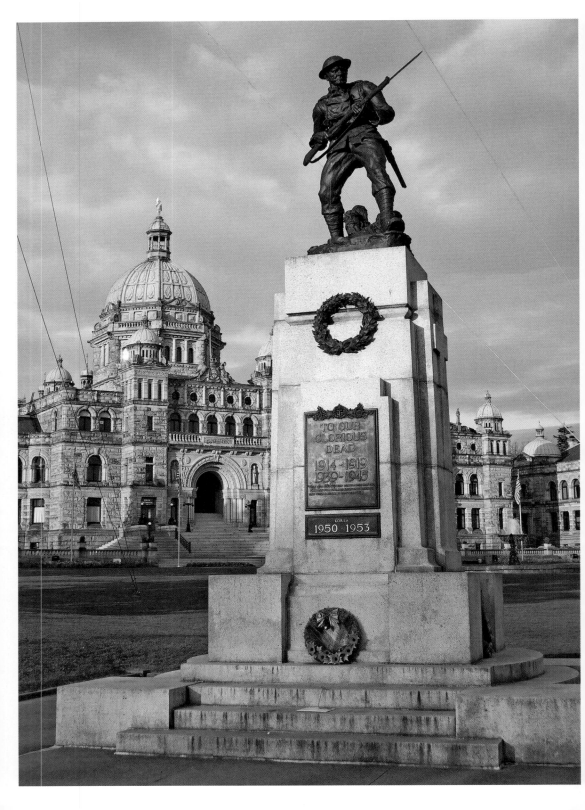

and identified; he has no known grave. He is one of 11,285 Canadians killed in France for whom a visit to a grave is impossible; they are all remembered on Canada's great national memorial at Vimy Ridge.

After enlisting in one Nova Scotia highland battalion, the 219th, Stanley Annis served at the Western Front with another, the Eighty-Fifth, Nova Scotia Highlanders. In August of 1918, the Canadian Corps embarked on its last great campaign of the war, the Hundred Days Offensive. By September of 1918, Stanley had survived two and a half years as an infantryman in the Canadian Expeditionary Force, and he had been promoted to Corporal. He had outlived his younger brother by almost two years. The Armistice was seventy days ahead.

On September 2, Stanley`s luck ran out: while advancing along the Arras-Cambrai road with the platoon under his charge, Corporal Annis was struck by enemy shrapnel and killed instantly. Stanley's "final resting place" is a short distance from where he fell, in a British military cemetery, Dury Mill. Almost all the graves at Dury Mill—324 of 336—are Canadian, most of them men killed the same day, 2 September 1918, the day the Canadians overran German defences along the Drocourt-Quéant line.

In all likelihood, a pilgrimage to the places their sons died would have been beyond the reach of the Annis parents. One conceives how significant Armistice Day ceremonies at the Liverpool war memorial might have been to Herbert and Clara, the Caledonia, Nova Scotia, father and mother who lost two sons in the charnel house of the Great War.

In the northeast corner of the legislature grounds, about midway between the striking British Columbia Legislature and the just-as-imposing Empress Hotel in Victoria, British Columbia, there stands on a grand granite base an unusual bronze soldier.

The Victoria bronze is the work of Sydney March (1867–1968), whose name is emblazoned in large lettering along the right side of the base. Sydney March was one of a remarkable family of eight siblings, every one of them a sculptor. March produced a diverse array of pub-

91

◄ OPPOSITE ... Sydney March; Victoria, British Columbia

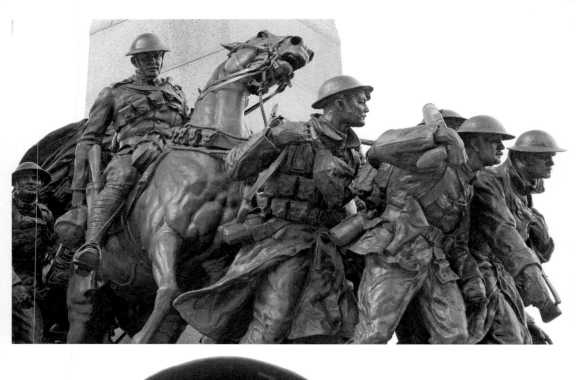

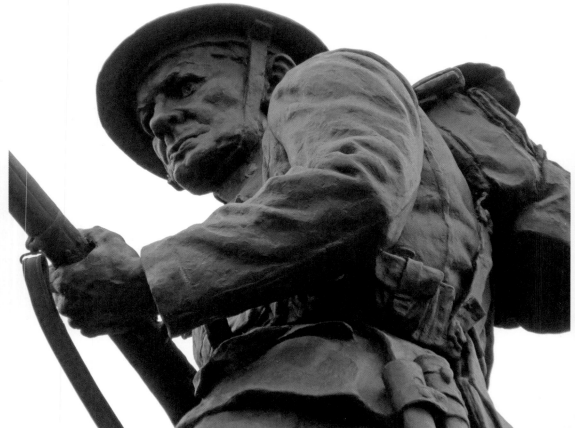

lic monuments, including at least two others in Canada: the United Empire Loyalist monument at Hamilton and, at Vancouver's Stanley Park, the monument to Canada's sixth Governor General, Lord Stanley of Preston, provider of hockey's Stanley Cup.

When the Canadian government decided to commission a national war memorial in the national capital, it was to the March family, principally Sydney's brother Vernon, that Ottawa awarded the commission. Vernon died shortly after the project commenced, but his siblings carried on without him. The monument features a great arch and twenty-two figures of men and women representing the military services contributing to Canada's war effort from 1914 to 1918. Commenced in 1926, the project would take years to complete; it was finally dedicated by King George VI in 1939 as war clouds were again building in Europe.

Sydney March's Victoria soldier takes a back seat to none of his other sculptures. The soldier is unique—in contrast to most of his stone and bronze comrades across the country, he is not handsome, he is not young, his face is one only a mother could love. He is a worn, weathered, ancient-looking infantryman wielding his Lee-Enfield, bayonet mounted, ready to deal with the enemy. Weather-beaten face notwithstanding, this is one of the finest war-monument soldiers in Canada.

Only a comparatively small number (fewer than a dozen) of soldier figures on Canadian war memorials are the work of American and British artists, but they include at least two—the Massey Rhind piper at New Glasgow, Nova Scotia, and Sydney March's grizzled infantryman at Victoria, BC—that can fairly be included in the first rank of Canada's bronze and stone monumental soldiers. To appreciate who rivals Rhind and March, we must turn to homegrown gems—monuments designed by Canadian sculptors working in Canada in the decade following the Great War. ∞

93

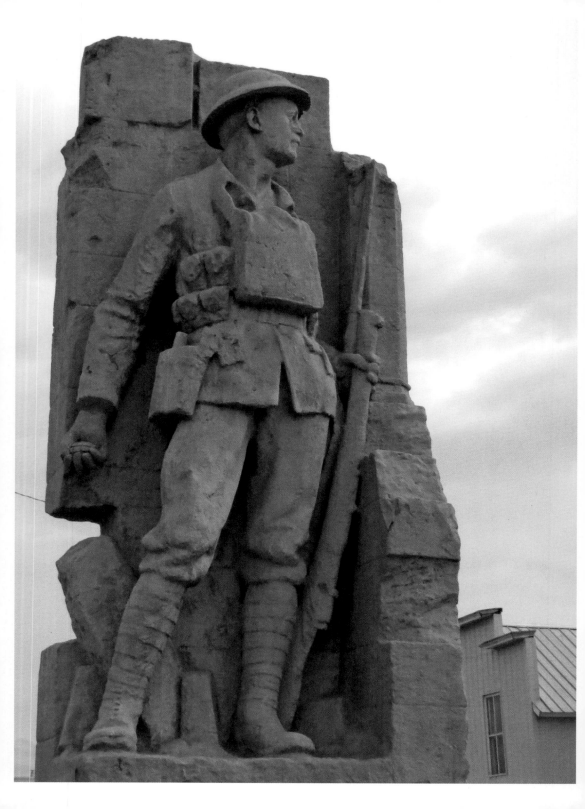

IV

*H*OME AND *N*ATIVE *G*LORY

CANADA'S WAR MEMORIALS FEATURE MORE than eighty bronze and stone figures conceived here at home by Canadians.

By comparison, the number of white-stone soldiers produced by Tuscany craftsmen for Canadian war memorials is almost a hundred. But it is only in sheer numbers that Canadian-designed monumental figures take a back seat to their foreign-made counterparts. The very best and most diverse of the country's memorial soldier figures are ones designed in Canada by Canadians.

A small number of made-in-Canada figures were produced by local craftsmen, but the majority of homegrown designs were conceived by well-established, esteemed Canadian sculptors and artists.

In this chapter, beginning with the remarkable Nicolas Pirotton, we survey Canada's own bronze and stone statuary in all its considerable range and artistic accomplishment.

THE AUTODIDACT

ST. CLAUDE, MANITOBA, IS A VILLAGE OF six hundred, reached by Manitoba Highway 240, south of Highway 2. It is off the beaten track, forty kilometres south of Highway 1, the Trans-Canada, at Portage la Prairie. Though its population is small, St. Claude is a busy, industrious, thriving community. It bills itself "The Dairy Capital of Manitoba" and has an ambitious dairy museum to buttress the claim. St. Claude has not just a summer rodeo but a winter carnival too.

The village has something else: a remarkable war memorial. In a small central park, the visitor to St. Claude cannot help but be struck by the multi-part village cenotaph. Two relic German machine guns and the flags of Canada and France flank a broad stone pedestal with a central column.

On the left of the base stands a Canadian "Tommy," an infantry soldier of the Great War, on the right, his ally, a French *poilu*. On the central column, a bust of Maréchal Ferdinand Foch, supreme commander of Allied forces on the Western Front in the last year of the war. The likeness of the bust to the real-life Foch is striking.

There is no other war memorial in Canada anything like the St. Claude array. Who was its creator? The group is the work of Nicolas Pirotton, and it is all the more remarkable for this: in contrast to virtually all of the Canadian artists producing war memorial sculptures in the years after the 1918 Armistice, Pirotton apparently had no formal training as a sculptor. He was self-taught. At the time of the outbreak of war, Pirotton was a stone-carver of established ability and some renown. Soon after the war's end, communities across the country were ardent to erect monuments to their fallen sons. Pirotton seized the opportunity, and he seized it with both hands.

Some 140 kilometres east of St. Claude is another community with a proud francophone heritage, St-Pierre-Jolys. Here, too, is an elaborate

97

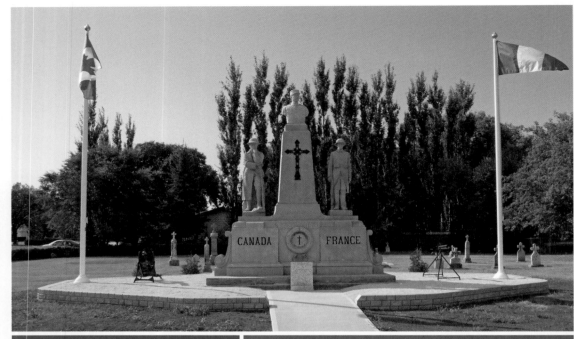

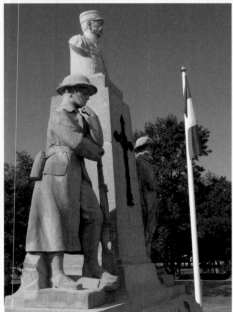

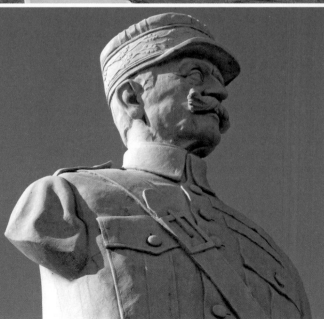

Nicolas Pirotton monument to the community war dead. Two figures stand on the monument base: on the left, a contemplative Canadian soldier, just like the one at St. Claude; beside him, on a higher column, a figure representing Joan of Arc, hands clasped, arms supporting a staff and flag—an inspiration to the soldier to do his best for himself, his community, his comrades-in-arms.

On the front of the pedestal, a marble panel under the heading "A la Glorieuse Mémoire de Nos Braves Tombés au Champ d'Honneur" lists eight names, five of them francophone—the names of the young men of St-Pierre-Jolys who died between 1914 and 1918. It is a list that meets the highest standard for war memorial commemoration, offering not just the name of the lost soldier, but his age, the date of his death, and the battle in which he died. The battle names are familiar: Albert, Vimy, Passchendaele, Bourlon Wood.

The eldest of the eight lost soldiers listed at St-Pierre-Jolys is twenty-six, the youngest just sixteen, the age Peter McBean had attained when he was killed in the battle for Hill 70, just north of Vimy, in August 1917. In theory, no boy under the age of nineteen was allowed to fight and spill his lifeblood for Canada, but like so many other Canadian youths keen not to miss out on the great adventure in Flanders, young McBean lied about his age. At the time of his enlistment in January 1916, McBean added four years to his true age, claiming to be eighteen, when he was in fact not yet fifteen. Even so, he was not the youngest casualty of the Great War. Not by a stretch.

Nicolas Pirotton's rendering of a Canadian soldier at both St. Claude and St-Pierre-Jolys—the soldier's left arm bent at the elbow, chin resting on the hand, the right hand supported by his rifle—is

99

◄ OPPOSITE ... Pirotton; St. Claude, Manitoba

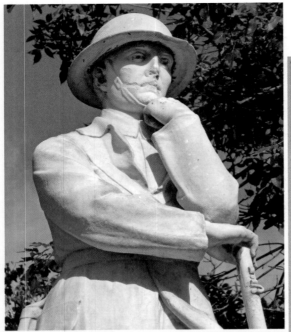

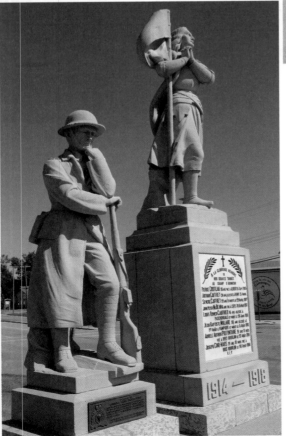

A LA GLORIEUSE MÉMOIRE
DE
NOS BRAVES TOMBÉS
AU CHAMP D'HONNEUR
PIERRE CROTEAU 26 ANS TUÉ À ALBERT 15 SEPT. 1915
ARTHUR CAFFREY 24 ANS, BLESSÉS À VIMY 15 AVRIL
SÉVÈRE CAFFREY 22 ANS ET MORTS LE 29 AVRIL 1917
JOHN PETER McBEAN 16 ANS. TUÉ À CÔTE 70.15 AOÛT 1917
LOUIS ROMEO GAUTHIER 18 ANS. BLESSÉ À
PASCHENDALE ET MORT LE 28 JANV. 1918
JEAN BAPTISTE MULAIRE 20 ANS, BLESSÉ LE
1ER AOÛT A FAMPOUX ET MORT LE 3 AOÛT 1918
AURELE ARTHUR PREFONTAINE 21 ANS 11 MOIS.
TUÉ À BOIS BOURLON LE 27 AOÛT 1918
JOSEPH CINQ-MARS 22 ANS 10 MOIS TUÉ À
BOIS BOURLON LE 28 AOÛT 1918
R. I. P.

△ CLOCKWISE FROM TOP LEFT ...
Pirotton; Weyburn, Saskatchewan

Cenotaph, Saint-Pierre-Jolys, Manitoba

Pirotton; Saint-Pierre-Jolys, Manitoba

▶ OPPOSITE, CLOCKWISE FROM TOP ...
Cenotaph, Gananoque, Ontario

Pirotton; Brockville, Ontario

Pirotton; Gananoque, Ontario

DONALD ERIC TURNER · ROBERT LUCY
OSCAR LLOYD · MILLARD WRIGHT
JOHN LEAKEY · ALFRED STUNDEN
ROLFE McKEIL · CHARLES MATTHEWS

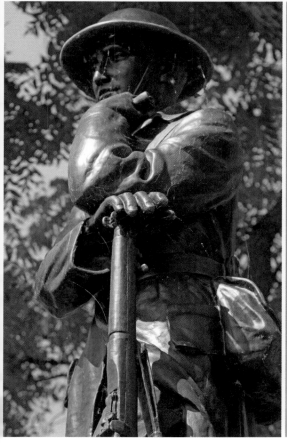 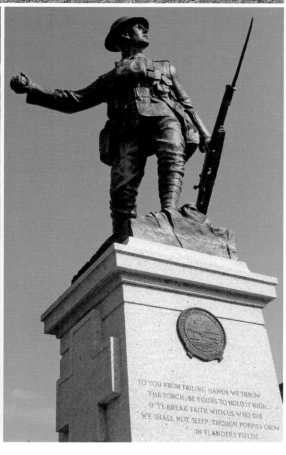

TO YOU FROM FAILING HANDS WE THROW
THE TORCH, BE YOURS TO HOLD IT HIGH.
IF YE BREAK FAITH WITH US WHO DIE
WE SHALL NOT SLEEP, THOUGH POPPIES GROW
IN FLANDERS FIELDS.

echoed in other Prairie communities: Emerson and MacGregor in Manitoba, Weyburn in Saskatchewan. The face of the stone Weyburn figure betrays both natural and intentional human-inflicted ravages.

Not all of Pirotton's figures are carved in stone. His reach went beyond Manitoba and his designs were realized in bronze as well as stone. At Gananoque, Ontario, a bronze iteration of a soldier in the familiar Pirotton attitude stands on the community war memorial in an attractive park in the centre of town.

The granite pedestal at Gananoque is handsome: in addition to the inscribed names of the town's war dead, nine bronze regimental badges encircle the top of the pedestal. These represent the military units in which the young men of the town discharged their duty to "King and Empire."

One of the names inscribed on Gananoque's war memorial is Rolfe McKiel. A twenty-one-year-old native of Gananoque, Second Lieutenant McKiel was killed when his Avro 504 crashed on landing at the aerodrome at Gullane, Scotland, 6 September 1918. Another airman stationed at Gullane that day was a future member of the Hockey Hall of Fame, Frank Fredrickson, who at the time was a test pilot and flying instructor at Gullane. Fredrickson's journal entry for September 6 includes this reference to McKiel:

> I was soon to feel depressed and a little sad, for the remains of a Canadian, McKiel by name, was carried into a neighbouring room by four Americans. He had been killed in early morning while attempting a landing. He occupied the front seat, and a brother officer the back seat of the Avro. After the doctor had gone I looked at his ghastly face that bore a deep cut over the right eye. With the sign of the cross over his body I prayed for his soul and his people.

One more Nicolas Pirotton design commands attention. On the main street of Brockville, Ontario, on a height of land facing the St. Lawrence River and Morristown, New York, on the opposite bank, a purposeful bronze infantryman is set to launch a grenade into enemy

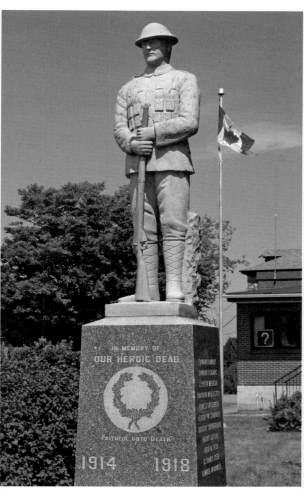

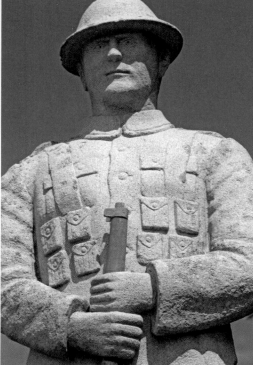

ranks. The bronze figure stands high on an ornate and beautiful base, featuring details of a soldier's gear: helmet, kit bag, bullet pouches, water flask.

The Brockville monument is the work of the McIntosh Granite Company of Toronto, one of the three principal Canadian manufacturers of war memorials in the post-war years. The monument at Gananoque is another McIntosh piece.

Pirotton is the most accomplished of the autodidact artists who created stone and bronze soldiers for Canadian war memorials in the 1920s, but he is not the sole one.

The monument-seeker travelling on back roads across the country occasionally finds a stone soldier that is conspicuously not the product of a talent such as that displayed at St. Claude but of a country craftsman who, while his hands may not have been in Pirotton's league, had a heart that was entirely in the right place.

One such figure graces the war memorial at Dorchester, New Brunswick.

Dorchester boasts of having the world's biggest sandpiper—albeit one that doesn't fly—and the oldest stone building in the province, erected in 1811. The polished granite base of the town's war memorial bears the names of twenty-two Dorchester men who died in the Great War.

Standing on the Dorchester monument is a simple, unsophisticated rendering of a Canadian soldier. The figure was likely carved by a local tradesman whose background evidently did not include formal training as a sculptor and whose name appears forever lost.

The stone soldier of Dorchester is at one end of the spectrum of artistic accomplishment reflected in war memorial statuary produced in Canada by Canadian artists in the years following the end of the war. But it seems likely that the naiveté of the stone-carver mattered little to the people of Dorchester.

The regard of Dorchester townsfolk for their war memorial and for the young men honoured and remembered by it is reflected in a 1995 book, *One Village, One War: A Thinking about the Literature of Stone*, by Douglas How. How's book addresses forty-one men—the twenty-two listed on the Dorchester monument who died in the Great War and nineteen more who perished in its 1939–1945 sequel.

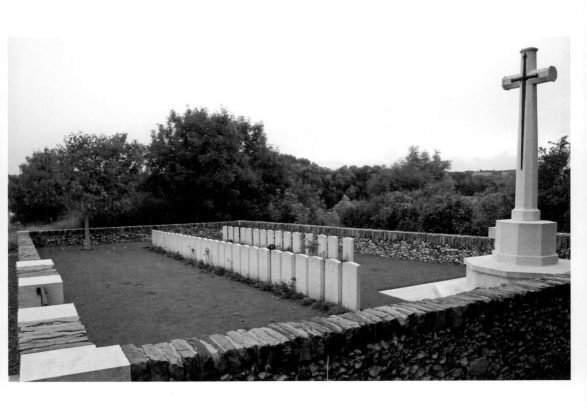

Demuin British Cemetery, France

One of the names remembered "forever more" at Dorchester is Harvard McAllister. Harvard was still seventeen, a young bank clerk, when he enlisted in September 1914 soon after the declaration of war. Though wounded in 1916, he survived nearly four years at the front lines, only to be killed in action during the intense fighting at Hangard Wood, just three months before the war's end, 8 August 1918, "the Black Day of the German Army." By the end of the line, Lance-Corporal McAllister had reached the ripe old age of twenty-one.

He is buried in tiny Demuin British Cemetery in the Department of the Somme. The cemetery, at the side of the road descending into Demuin village, contains just forty-two graves, forty of them honouring Canadians killed the same day as Harvard McAllister.

Travel from Dorchester to the battlefields of the Western Front was a far more onerous proposition in 1920 than it is today; it is likely that his parents never saw Harvard's grave. For them, the humble, heartfelt soldier rendering at Dorchester was all they required. When the McAllister parents assembled on Armistice Day with others to pay homage to the lost boys of Dorchester, they were moved by the same grief—and inspired to honour the same rites of remembrance—as motivated the legions of mothers and fathers gathered before grander monuments elsewhere in the country.

ROGERS-TICKELL BRONZE, McINTOSH GRANITE

THE HEAVY GUNS OF THE Western Front had barely fallen silent when in late November 1918 the people of Sarnia, Ontario, were already wrestling with the question of how to remember and honour the men and boys of the city who had died in the war. Proposals were varied. Someone suggested planting 228 oak trees, one for every fallen soldier, with plaques naming each of them. Another proposed a public building to their memory—a library or YMCA. Someone else mooted a veterans' home with swimming pool and billiard tables.

A mother weighed in with a heartfelt letter inspired by the loss of her boy, Leonard Calvin McMullin, killed in action 25 May 1918 and buried in the same British cemetery as Harrison Livingstone's beloved

brother, Daniel, at Wailly Orchard, just seven kilometres southwest of Arras. Leonard was nineteen at the time of his death. Here is part of what Irene McMullin had to say about the monument she felt would be worthy of her boy and the other lost sons of Sarnia:

May I speak for my boy? He is sleeping somewhere in France . . .

Reader, have you a boy sleeping over there? If so, does not the little white wooden cross seem a frail thing? And many of our precious boys have not even that much. A granite monument would be a memorial which would withstand the elements for many generations to come and in that way would perpetuate their names as nothing else could. Also it would be something which the residents of our city and visitors as well, would have cause to admire and revere. Furthermore, if this proposed memorial to the boys who have lost their lives should take the form of a home, or a Y.M.C.A. or Y.W.C.A, it would be natural for the original motive to be lost sight of, within a few years . . .

In the years of the future, when one by one our returned heroes have gone to their reward in the Great Beyond, their earthly remains laid to rest beside their father and mother, perhaps, their names and record engraved upon the family monument . . .

The little white wooden crosses over there seem to send us the message "Do not forget us," though only wrapped in a blanket, perhaps and buried khaki clad, in a soldier's grave.

Mrs. McMullin won the day. A visitor to Veterans Park in Sarnia today sees a fine granite monument bearing the names of the 228 men who went off to the Great War and never came back. On the face of the pedestal these words are inscribed: "To keep forever living the freedom for which they died this symbol has been dedicated to the fallen."

On top of the Sarnia cenotaph, there is a bronze soldier standing smartly at attention, rifle strapped over his left soldier. The base of the bronze identifies its fabricator: Canadian Wm. A. Rogers Limited, Bronze Founders, Toronto.

107

In the years immediately after the end of hostilities in the war of 1914–1918, a number of entrepreneurs rose to the challenge of meeting the flood of demand from communities across the country for monuments to their fallen soldiers. Three of these, all based in Toronto, were the giants in the market. They were the McIntosh Granite Company, the Thomson Monument Company, and William A. Rogers Limited, which later morphed into F.G. Tickell and Sons.

Identified bronzes produced by the Rogers-Tickell firm are to be found at several Ontario locations—Durham, Sarnia, St. Thomas, and Queenston—and at Wolfville, Nova Scotia. Another Ontario figure, at St. Mary's, shows no identifying marks but exhibits all the distinctive features of the Rogers-Tickell brand.

The Rogers-Tickell figures are all like the Sarnia model. Though well proportioned and technically well executed, the Rogers-Tickell figures are not particularly dynamic, expressive, or evocative. Typically, the soldier stands stiffly at attention, with rifle in hand or strapped to shoulder, eyes fixed indeterminately at some point on the horizon.

All of this places them in the same company as many of the standing-at-attention Italian marbles surveyed earlier. The difference, of course, is that the Rogers-Tickell soldiers are bronze—they are not weathered and eroded as are many of the white-stone Italian figures but are as vivid and whole as the day of their installation.

We have already surveyed two examples of the work of the McIntosh Granite Company—the Nicolas Pirotton-designed figures at Brockville and Gananoque. There are several other McIntosh monuments to be seen in Ontario; appropriately enough, given the company name, they are typically in granite. A benchmark McIntosh design is the figure at Walkerton, Ontario.

The granite soldier there is turned slightly to his right, looking alertly at something in the middle distance. The Walkerton soldier somewhat resembles the made-in-Italy figures we saw in Chapter II. But there are differences. Rather than a tree stump, the soldier's right leg rests against a British helmet. The soldier himself is out of the ordinary. The mouth is set, the jaw strong. He exudes resolve, determination, confidence—exactly the sort of look the people of Walkerton would have wanted the McIntosh artisans to attribute to their heroic boys who went off to war and never returned.

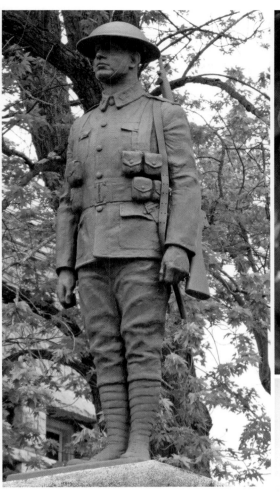

▲ *CLOCKWISE FROM TOP LEFT ...*
St. Mary's, Ontario

Wolfville, Nova Scotia

Walkerton, Ontario

Inscribed on the face of the town war memorial are these words to the "Brave Sons of Walkerton": "They gave their lives to the Empire and received each a home in the minds of men where their glory remains fresh, to stir to speech and action as the occasion comes by. Their glory shall not fade."

One of the brave sons remembered on the Walkerton memorial is George McLeod Rock. Rock was twenty-seven when he enlisted in the Forty-Fifth Battalion in December 1914, listing his trade as "Agent," and his next-of-kin his father, the Reverend G.C. Rock of Walkerton.

By November of 1917, now promoted to Lieutenant, George M. Rock was fighting with the Eighth Battalion in the misery and mire of Passchendaele. More than four thousand Canadians died at Passchendaele, and another twelve thousand were wounded. Among those soldiers who breathed their last on November 10 was Lt. G.M. Rock. Great War death records are normally very brief; by comparison to most, Lt. Rock's is richly detailed:

> *"Died of Wounds". He was the Battalion Scout Officer, and about 9 o'clock on the morning of November 10th 1917, during an attack on PASSCHENDAELE RIDGE, he went out on a reconnaissance with another Officer. When in the vicinity of VENTURE FARM he was hit in the neck either by a rifle or machine gun bullet. He was conscious for a time after being hit, and did not appear to be suffering, although he complained that his legs were stiffening as though paralyzed. A stretcher party was procured and he was carried to the dressing station and from there taken to No. 2 Australian Field Ambulance where he died the same day.*

Lt. George McLeod Rock is one of 155 Canadians buried at the large Ypres Reservoir Cemetery in Belgium.

◄ *OPPOSITE* ... Preston (Cambridge), Ontario

Doubtless the most remarkable of McIntosh monuments in Ontario is the figure at Preston, now part of the city of Cambridge. At Preston, a large stela sets out the names of the fallen in both world wars. The centrepiece of the monument is a Great War soldier, wearing a cape. His arms are fully outstretched, his gaze expressionless. The pose is striking and unusual; the observer is hard-pressed not to imagine that the designer meant for us to draw a connection between the fallen soldier and Christ on the cross. Inscribed above the soldier are the familiar words—"Their name liveth for evermore"—and words less familiar: "They were a wall of defence unto us."

An intriguing name appears among those of the fallen of Preston: William C. Ploethner. William Carl Ploethner was the grandson of German immigrants who arrived in Ontario in the mid-1800s. William was raised at Preston by his German-born grandmother, Martha Heise Ploethner. That William was a true-blue Canadian boy is suggested by this: in 1911 he was a member of the Ontario championship intermediate hockey team. Later, young William moved to Saskatchewan and married at age twenty-two.

When Canada declared war on Germany in 1914, it is easy to imagine that among the extended members of the Ploethner family there may have been mixed emotions about William doing his duty to "King and Empire." But whatever the family strains might have been, William enlisted in the Canadian Expeditionary Force and went to war against the Kaiser's armies, armies that doubtless included unknown numbers of his own first cousins. William's decision no doubt marked him as unusual: among the two-thirds of a million men and women who enlisted in the CEF, he is the only Ploethner.

While serving at the Western Front, William's wife back in Canada gave birth to a daughter. William wrote letters to his infant daughter from the front-line trenches. In the early summer of 1917, he received a "blighty," a wound serious enough to require extended treatment in England. He continued to write to his baby daughter. And he slowly recovered. Two days before he was scheduled to return to his unit at the front lines, 20 June 1918, William Ploethner went for a bicycle ride. It was his last—he was killed in a collision with a motor vehicle. He would never meet his daughter. William is buried at Penrith, Cumberland,

his one of forty-five war graves maintained by the Commonwealth War Graves Commission.

At Barrie, Ontario, on top of the city's tall war memorial, a stone soldier stands by a battlefield grave. By his right foot is an unfired artillery shell, in his right hand, a wreath. Given the context, it is entirely appropriate that the soldier's look conveys pure sadness and grief: he is mourning the death in battle of a beloved comrade-in-arms.

The stone soldier of Barrie is another of the works of the McIntosh Granite Company of Toronto. It was installed in 1922. Keep the Barrie soldier in mind when, later in this chapter, we come to a memorial soldier produced a year earlier by the McIntosh competitor—the Thomson Monument Company of Toronto.

THE ALLEGORISTS

WITH THE POSSIBLE EXCEPTION OF the national cenotaph at Ottawa, no Canadian monument to war is more familiar than the national memorial towering above Hill 145 at Vimy Ridge in northern France.

The white twin pylons of the monument soar thirty metres above the base. Twenty human figures adorn the monument, all in various states of undress, all of them allegorical, their meaning expressed not directly but symbolically. Eight figures clustered at the top of the pylons represent such human virtues as Justice, Charity, and Honour.

Two figures representing Canada's grieving parents sit on steps on the southern side of the monument.

Among those who appreciate war memorials there is a constituency who argue with great conviction that there is a place for allegory in war memorials—and that Vimy is exactly that sort of place. Defenders of allegory are certainly not rare; indeed it is entirely likely that no war memorial is more beloved by Canadians than the Vimy monument.

But it is interesting that among the twenty figures on the Vimy monument—a monument to the sixty-six thousand Canadian soldiers who died in the war and particularly to more than eleven thousand having no known grave—not one of the figures is a soldier the untutored observer would recognize as a soldier.

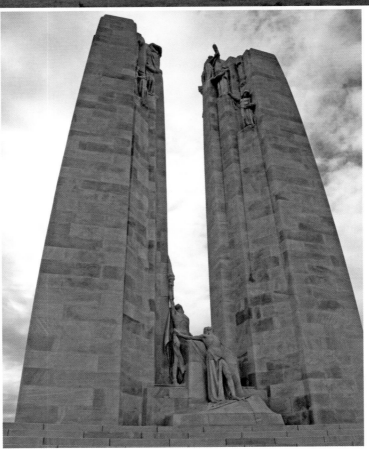

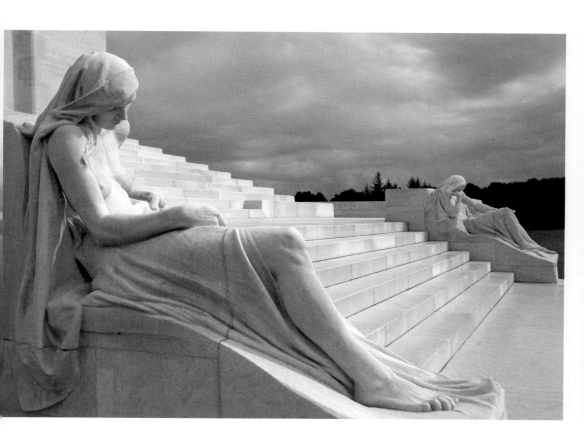

◀ *OPPOSITE AND ABOVE* ... Walter Allward;
Canadian National War Memorial, Vimy Ridge, France

Two figures on the base, between the pylons, are designated the Spirit of Sacrifice. These are meant to represent soldiers, albeit ones the uninformed viewer recognizes only with the aid of expert interpretation: a dying soldier passes the torch to a comrade. Being symbolic rather than strictly representational, the figures are not dressed in raiment that would be recognized by a knowing student of the Canadian Expeditionary Force.

The Vimy monument reflects the genius of Walter Allward, winner of the competition the federal government launched in the early 1920s to determine a design for the edifice the government wished to build in the battlefields of France. Allward commenced his important task in 1925 and would take eleven years to complete it. The final cost of the project was some $1.5 million, more than $25 million in present-day terms.

More than a hundred thousand people attended the 1936 dedication ceremony, many of them Canadians, including some nine thousand veterans of the war. It was a very grand event, and Allward's masterpiece drew impassioned praise from every quarter.

When the Great War–Part II broke out in 1939 and Adolf Hitler's armies invaded France, there was considerable worry in Canada that the Führer might do damage to the monument commemorating Canada's part in the Allied victory of 1918. They needn't have fretted.

Prior to 1914, Hitler had himself been an artist of modest ability and reputation. He went to Vimy in 1940 not to ravage Allward's gem but to admire it. The monument survived the Second World War entirely unscathed.

Back home in Canada, Walter Allward had completed two community Great War memorials, at Peterborough and Stratford, Ontario. Like his Vimy monument, the Ontario conceptions are allegorical, or strictly symbolic. Peterborough's monument, refurbished and improved in 2010, is a very ambitious piece of work.

Twelve granite blocks set out the names of more than ten thousand Peterborough men who served in the world wars and Korea. But do not go there expecting to see a vivid effigy of a Canadian soldier. At Peterborough, the visitor beholds two semi-clad figures, each facing the other. One grasps a sword in his right hand and holds up his

left in the fashion of a traffic warden instructing motorists to stop. The facing figure is buckled backwards, hand on fevered brow, close to collapse. What is this about?

One learns on inquiry that the monument represents the triumph of Civilization over Barbarism. Or, less subtly, of Britain and its dominions over Germany in the Great War.

The Stratford monument is in a similar vein. Here again we have two male figures attired in very little at all. In this case, they do not face each other but are back to back.

We are given to understand that the figures represent the triumph of Heroism over Barbarism. The vanquished barbarian covers his head in shame and mortification; the conquering hero lifts his eyes heavenward, grateful to the Greater Power for his triumph.

Those who prefer allegory and symbol over natural representation have another Canadian artist to admire. The monument-seeker who goes to Sault Ste. Marie, Ontario, finds an example of his unusual work.

Standing on the pedestal in front of the Sault courthouse is the figure of a woman. Raised high in her left hand is a sprig of oak leaves; clutched in her right, a sword. Her left foot presses heavily on a shield under which a naked male figure cowers, bent double. He is bedraggled and beaten.

What to make of Alfred Howell's construction? Before comprehending just what message we are meant to take from these figures, there is an extended moment of confusion. In that moment, one wonders, for which face are we meant to feel sympathy—the triumphant woman or the forlorn man? Then it dawns: the man's right hand rests on a German helmet of the Great War.

The Sault Ste. Marie monument is another metaphor: it, too, celebrates the triumph of Civilization over Barbarism.

Two bronze panels on the monument are also by Alfred Howell but point to a very different message from that of the bronze woman and man, one that is not at all triumphant. In the first panel, a group of soldiers stand tall, looking resolute, stalwart, and strong. They are bidding farewell to loved ones, a daughter, brother, father, and mother. The scene radiates confidence and well-being.

◀ *OPPOSITE, CLOCKWISE FROM LEFT ...*
Walter Allward; Peterborough, Ontario

Allward; Peterborough, Ontario

Allward; Stratford, Ontario

▲ *ABOVE LEFT ...* Allward; Stratford, Ontario

▲ *ABOVE RIGHT ...* Alfred Howell; Sault Ste. Marie, Ontario

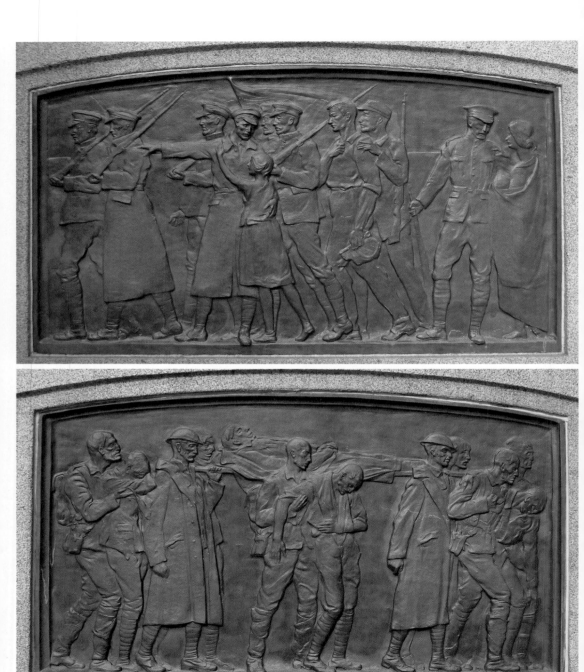

The second panel conveys something else entirely. A group of twelve soldiers, not one of them reflecting the strength and purpose of the men in the first panel, make their sorry way to a front-line dressing station or field hospital. Several of the soldiers are wounded, one on a stretcher, another with his arm in a sling, two more with heads hung low. Even the healthiest-looking appear worn down, emaciated. The juxtaposition of the panels offers a powerful statement about war that is anything but triumphant.

Men go off to war full of robust vigour and enthusiasm, ardent and confident. They are keen to take their role in the Great Game, worried about speculation that it might all be over by Christmas. They have no idea what they are getting into. When reality rears its ugly head, all the eagerness and confidence is gone.

It is unlikely to have been Howell's intention, but his monument at Sault Ste. Marie imparts entirely opposite messages—one pointing to the glory of war, the other to its unspeakable misery. Howell's Sault Ste. Marie panels are hugely affecting.

Alfred Howell produced war memorials for five Canadian communities—four in Ontario, one at Saint John, New Brunswick. Two of the Ontario monuments, at Pembroke and Oshawa, are straight-ahead, naturalistic effigies of Canadian soldiers. The other two, at Saint John and the group at Guelph, Ontario, are cut from the same bolt of cloth as his Sault Ste. Marie figures.

Three figures stand on the imposing Guelph monument. The closest to the base is the figure of a woman, in bronze. Arms outstretched, she grasps swords in both hands. A wreath rests on the crossguard of each. Above this figure stands a soldier, carved in granite. He looks over his left shoulder at a book in the hands of another female figure, who points at the book and gazes heavenward. What is the message Howell intends us to take from his Guelph grouping? The answer is not straightforward. Various interpretations may provide clarity.

121

◄ OPPOSITE … Howell; Sault Ste. Marie, Ontario

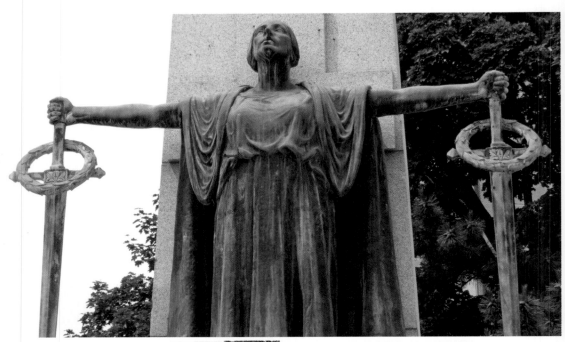

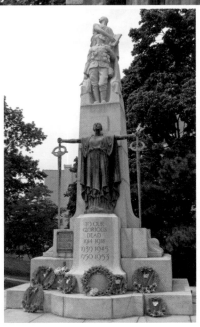

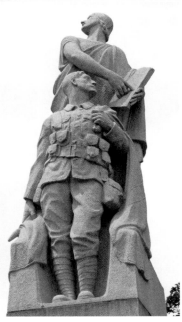

Here is one: the bronze woman at the base stands for victory, the victory achieved not just by the individual soldier but by all his comrades in the Canadian Corps. The soldier, though he appears intact, is one of the fallen. His agent—an angel, perhaps?—points to the book of the soldier's virtues and achievements in life and argues to St. Peter that the soldier richly merits a place in heaven with the other righteous and deserving souls residing there. No interpretative panel explains the artist's intention at Guelph. The observer is left entirely to her own devices. The interpretation offered here may be entirely mistaken, which perhaps explains some of the difficulty that century-old allegory presents to modern sensibilities.

We now move on from the allegorists to their 1920s competitors, artists who present no such difficulties to monument-seekers ardent to decipher the meaning of the bronze and stone soldiers of the Great War.

FATHERS AND SONS

AT TINY MALPEQUE, PRINCE EDWARD ISLAND, in front of the historic 1869 Gothic Revival Princetown United Church, a war memorial features an attractive shield-shaped bronze panel setting out sixteen names: the "brave and noble sons who gave their lives for home, empire and freedom in the war of 1914–1918." At the foot of the table is the well-known but not universally embraced Latin phrase: *Dulce et decorum est pro patria mori.* Not everyone who lost a son or nephew—or perhaps three—was likely to agree that it is sweet and glorious to die for one's country.

Three of the Malpeque fallen bear the same surname: McGougan. Doubtless each was the close blood relative of the others. All three listed their occupation as farmer at the time of their enlistment. David

123

and John McGougan travelled together to join the Sixth Canadian Mounted Rifles on the same day, 6 August 1915, at Amherst, Nova Scotia. Their service numbers are consecutive: 111362 and 111363.

David died at age twenty-four after the Armistice, on Boxing Day 1918—perhaps a victim of Spanish influenza—and is buried in the church cemetery just behind the monument that honours him. John died shortly after the Battle of Vimy Ridge at age thirty-three and lies in Lievin Communal Cemetery Extension, a few kilometres west of where he died. The third McGougan, George Russell, was killed in action 22 August 1917 in the Battle for Hill 70 whilst serving in the Forty-Seventh Battalion. He was twenty-five. George has no known grave. His is among more than eleven thousand names inscribed on Canada's Vimy memorial: the toll of Canadian fallen in France for whom a kinsman's visit to see his relative's grave is impossible.

Standing on top of the Malpeque monument is a bronze soldier, an exultant one in the Bernard Partridge mould, brandishing a flag in his right hand, clutching a rifle in his left. The fine figure is the work of Hamilton Thomas Carlton Plantagenet MacCarthy (1846–1939), a prolific, highly regarded Canadian sculptor whose famous subjects include Champlain, Isaac Brock, Alexander Mackenzie and John A. Macdonald. MacCarthy's public works are displayed from Halifax to Victoria, and many places in between.

The population of Malpeque is fewer than two hundred in the off-season, considerably greater in summer when tourists arrive to gorge on lobsters and the prized oysters of Malpeque Bay. Funds for the monument are said to have been raised by ordinary people in Malpeque and nearby communities. But how did it come to pass that such a prestigious artist as MacCarthy was persuaded to produce the bronze soldier for the war memorial at little Malpeque? The cost of a MacCarthy bronze would ordinarily have vastly exceeded what the community would pay for a Carrara marble fashioned by an anony-mous craftsman on the Tuscan coast of Italy.

Did a wealthy benefactor wish to go over the top in honouring a son or nephew included among the Malpeque dead? Did MacCarthy feel a particular affinity for the north shore of Prince Edward Island? Did something move him to produce the memorial figure at a deeply

124

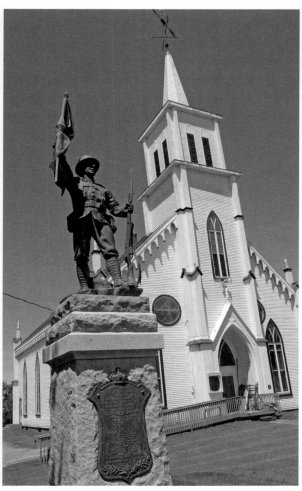

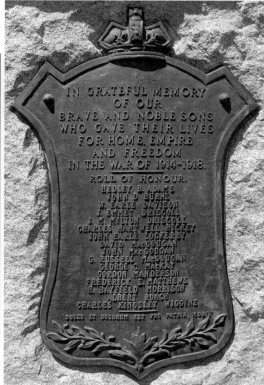

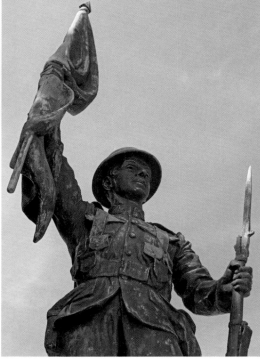

▲ CLOCKWISE FROM TOP LEFT ...
Hamilton MacCarthy; Malpeque,
Prince Edward Island

Cenotaph, Malpeque, PEI

H. MacCarthy; Malpeque, PEI

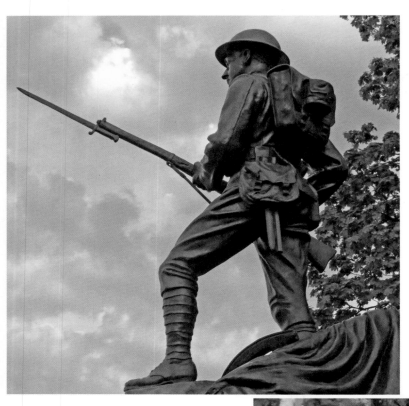

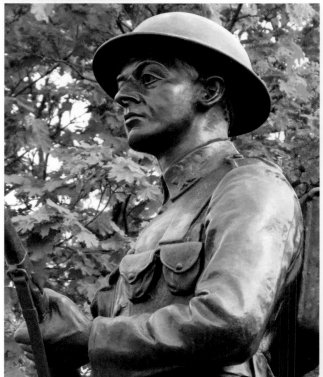

H. MacCarthy; Dundas, Ontario

discounted rate? The answer may or may not have been known in 1921, but today it seems lost in the mists of time. We will likely never know.

MacCarthy was seventy-five when he produced the Malpeque monument, his halcyon days well behind him, but Malpeque was not his swan song; he crafted another Great War monument, for Dundas, Ontario.

MacCarthy's Dundas soldier was unveiled 11 December 1921 by the Honourable Henry Cockshutt, Lieutenant-Governor of Ontario. The unveiling was no small occasion. The assembled crowd marched from the Dundas Armoury to the town centre, where His Worship Mayor Edmund J. Mahony presided over the ceremony. It opened with the singing of "Nearer My God to Thee." After the official unveiling by the Lieutenant-Governor, the crowd joined in another hymn, "Lest We Forget," followed by the dedication and address by the Reverend J. M. MacDonald. There was more: another hymn, "Oh God, Our Help in Ages Past," then a quartet of short addresses from important persons. Following all that, those attending sang "O Canada," a bugler played the "Last Post," a benediction was given and the event concluded with a final burst of the enthusiastic, loyal anthem, "God Save the King."

There was nothing at all unusual about the lengths to which the citizens of Dundas went to build their monument and honour their war dead. Such ceremonies were commonplace all across Canada in the early 1920s, as people gathered to dedicate war memorials typically paid for by ordinary citizens, through public subscription, not by governments or well-heeled sponsors. Citizens appeared in their thousands at such events to express their infinite grief and pay their undying respects to the young men who never came home.

It was not just at sculpting public monuments that Hamilton MacCarthy was prolific. He sired at least twelve children; some sources claim there were fifteen. One of these was a son with an unforgettable name who would surpass his father as a Great War sculptor. Coeur de Lion MacCarthy (1881–1979) lived long—ninety-eight years—and produced an array of war monuments whose range of expression exceeds that of any of his fellow war-monument sculptors working in Canada in the decade after the Great War. Perhaps it is no surprise: what else could a young fellow do with the name "Heart of a Lion" bestowed on him by his father?

127

MacCarthy the younger produced war memorial sculptures in seven diverse designs. One of his best known—and most cherished by some—is the product of the commission he was awarded by Canadian Pacific Railway to commemorate those of its employees who fought and died in the 1914–1918 war. The contribution to the war effort by CPR employees was formidable: more than 11,000 enlistments, 1,116 killed, more than 2,100 wounded—a casualty rate of close to 30 per cent. Two of the rail company's employees were awarded the Victoria Cross.

MacCarthy produced three iterations of the CPR masterwork he called *Winged Victory*—one each for the rail stations at Montreal, Winnipeg, and Vancouver. The piece reflects its era, one in which mothers and fathers wanted to believe—and many did believe—that there was something beyond the grave for their beloved sons lost in Flanders and France.

In MacCarthy's conception, the body of a dead soldier—dead but still handsome and showing no damage at all—is conveyed to heaven on the arm of a winged angel. With her left hand, the angel holds a laurel wreath high over the soldier's head.

One other MacCarthy design ventures into similar symbol and allegory. At Knowlton, Quebec, there is another angel and another soldier. In this case, the soldier is very much alive. The soldier stands, rifle resting on shoulder, pondering the scene before him. Standing behind the soldier, the angel is about to sound a trumpet. One presumes the angel, having chosen which side in the impending battle is the one invested with virtue, honour, and justice, is urging the soldier on to battlefield triumph.

The CPR and Knowlton pieces are the only ones in MacCarthy's war memorial portfolio that venture into symbol and allegory. The

▶ *OPPOSITE, TOP LEFT , TOP RIGHT, AND BOTTOM LEFT ...*
Coeur de Lion MacCarthy; Vancouver, British Columbia

▶ *OPPOSITE, BOTTOM RIGHT ...* C.d.L. MacCarthy; Verdun, Quebec

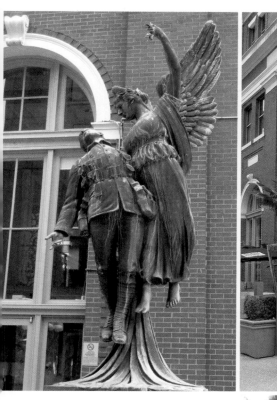
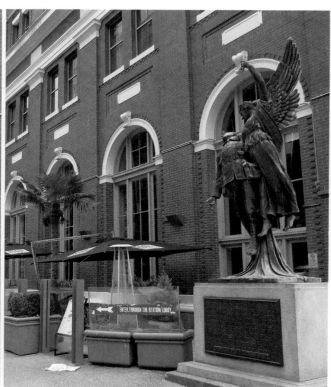
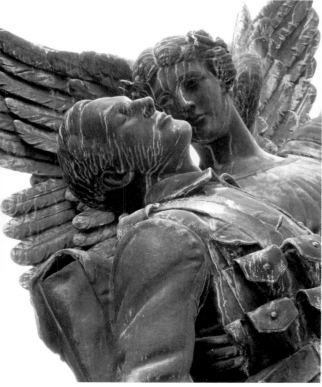
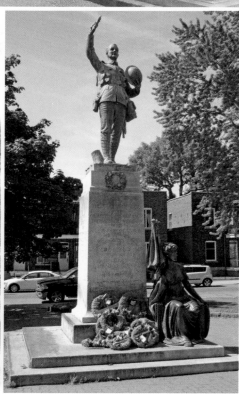

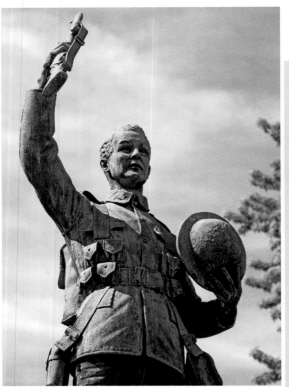

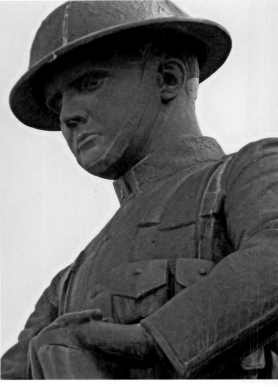

▲ *CLOCKWISE FROM TOP LEFT ...*
C.d.L. MacCarthy; Verdun, Quebec

C.d.L. MacCarthy; Lethbridge, Alberta

Frederick Chapman Clemesha;
St. Julien, Belgium

others all represent soldiers doing soldierly things. At Verdun, Quebec, a woman sits at the base of a pedestal on which stands a jubilant soldier in the Bernard Partridge mould. He holds his helmet in his left hand, his rifle in the right, his arm raised high in celebration. The soldier has conquered his own fear, he has "come through," and he has vanquished the enemy.

Side panels list the iconic battles in which the Canadian Corps achieved its great victories and established its reputation as the shock troops of the British Army: Vimy Ridge, Hill 70, Passchendaele, Drocourt-Quéant, Canal du Nord, Cambrai.

Another MacCarthy memorial figure, at Goderich, Ontario, is in a similar vein, except elements are reversed: the soldier's helmet lifted victoriously high in the right hand, his rifle in the left. Like the Joseph Whitehead bronze at Lunenburg, Nova Scotia, these MacCarthy figures are monuments that speak to the glory of war, not its pity.

Not all of MacCarthy's war memorials are so celebratory. His bronze soldier at Lethbridge, Alberta, conveys a message entirely different from that delivered by the Verdun and Goderich figures.

When the Canadian government launched a competition in the early 1920s to choose a design for the national war memorial it intended to build in France, it was the Walter Allward design, now beloved and familiar to battlefield visitors, that prevailed. But a second design, *The Brooding Soldier,* by Regina sculptor Frederick Chapman Clemesha, was so well regarded that the government decided to go ahead with both.

The original plan was to use the Clemesha design to mark eight significant Canadian battlefields of the war, but in the end it was determined that the realization would be unique: it would be installed at one important site and nowhere else. Clemesha's figure, depicting a brooding soldier, head bowed, hands resting on arms reversed, was erected at St. Julien in Belgium, scene of the great Canadian success in the Second Battle of Ypres in April 1915. *The Brooding Soldier* was installed at St. Julien in 1923.

Coeur de Lion MacCarthy's Lethbridge figure, not realized until 1931, strongly evokes Clemesha's design at St. Julien. If imitation is the sincerest form of flattery, Clemesha must have felt well flattered by MacCarthy's work at Lethbridge: a soldier stands with lowered head,

131

hands resting on arms reversed. Nothing about him conveys jubilation or exultation. He is pensive, contemplative, sombre, sad.

These words appear on the front panel: "In honour of those whose names endure ... They have passed on leaving the heritage of a glorious memory." On the sides of the pedestal are listed the names of 157 men of Lethbridge who died in the war.

The 7 June 1931 unveiling was another hugely attended ceremony. The remarks of Alberta Lieutenant-Governor William Legh Walsh may strike a present-day ear as somewhat high-flown, but his words would have sounded perfectly apt for the 1931 occasion, entirely suitable and appropriate:

> Unfortunately, it is one of the frailties of our human nature that we often neglect or entirely forget events and persons whom we should hold in imperishable memory. The erection of this splendid memorial and the unveiling today, in such an impressive ceremony in the presence of the large concourse of people, is conclusive evidence that no reproach can be laid at the doors of the people of this district that they have forgotten the men who, leaving their homes and their families and everything else near and dear to them, cheerfully laid down their lives in defence of the cause which they believed to be that of right and justice against the forces of tyranny and oppression.

Coeur de Lion MacCarthy's sculpture at Niagara Falls, Ontario, strikes another note, entirely different from the designs we have seen. At Niagara Falls, the MacCarthy soldier stands proudly on a tall pedestal at the edge of a large park, largely ignored by hordes of tourists who have eyes only for the great falls roaring just below. With helmet held casually in his left hand, the soldier looks confident, assured, one might even say haughty. What's more, he is distinctly good-looking, at one extreme of a spectrum whose opposite end is manifested by the Sydney March figure at Victoria seen in the previous chapter.

The monument's inscription is familiar—God is glorified and gratitude is expressed to the fallen of the community—then this: "Behold, this stone shall be a witness unto us."

▲ CLOCKWISE FROM TOP LEFT ...
C.d.L. MacCarthy; Niagara Falls, Ontario

C.d.L. MacCarthy; Niagara Falls, Ontario

C.d.L. MacCarthy; Trois-Rivières, Quebec

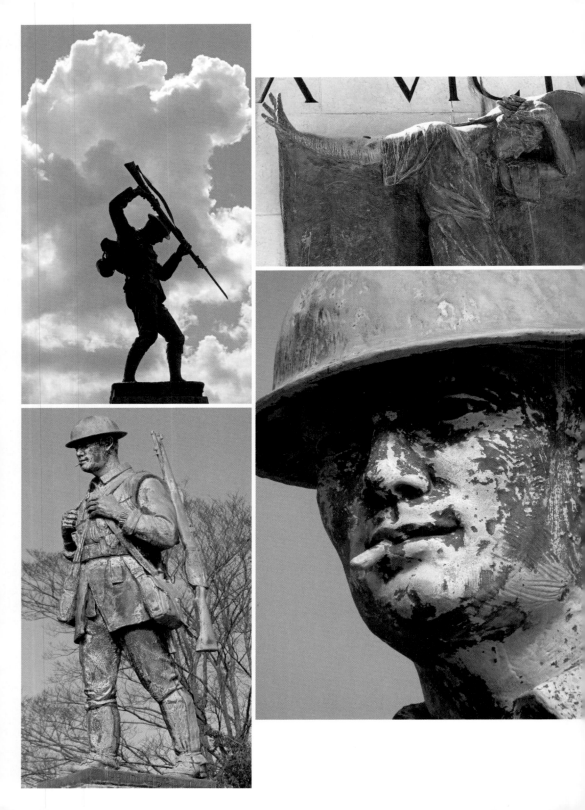

The people of Trois-Rivières, Quebec, are witness to something else entirely. The Coeur de Leon MacCarthy bronze at Trois-Rivières is extraordinary. More candidly than any war memorial figure in Canada, it tells a core truth about the soldier at war: his primary business is killing the enemy. Here the soldier looks down at a vulnerable adversary, poised to bury his bayonet in the enemy's gut. He is all business—focused, determined, coiled tight. MacCarthy's message in Trois-Rivières could not be more at odds with the one conveyed at Lethbridge.

The monument inscription at Trois-Rivières is every bit as unsentimental as MacCarthy's bronze. There is no grandiloquent message about Right and Justice prevailing over Tyranny and Oppression, only this, in both languages: "A Nos Soldats—To Our Dead Soldiers—1914–1918."

Another father-and-son combination made its mark on the Canadian sculptural landscape in the years prior to and following the Great War. Louis-Philippe Hébert (1850–1917) departed this mortal coil too soon to have had an impact on post-war memorial statuary, but he left a wide array of public monuments to such famous subjects as John A. Macdonald, George-Étienne Cartier, Plains of Abraham generals Wolfe and Montcalm, Queen Victoria, and King Edward VII.

He left something else, a son, who would sculpt one of the best and truest representations of a Canadian soldier on any war memorial installed in the post-war years.

Henri Hébert (1884–1950) produced just two war memorial figures. One, at Outremont, Quebec, depicts a grieving woman lamenting a husband or brother slain in battle at the Western Front. It is an attractive monument that doubtless spoke loudly to mothers,

135

◄ OPPOSITE, CLOCKWISE FROM TOP LEFT ...
C.d.L. MacCarthy; Trois-Rivières, Quebec

Henri Hébert; Outremont, Quebec

Hébert; Yarmouth, Nova Scotia

Hébert; Yarmouth, Nova Scotia

wives and daughters left with only anguished memories of a beloved lost soldier.

Henri Hébert's second memorial figure adorns the war monument at Yarmouth, Nova Scotia. Like Coeur de Lion MacCarthy's remarkable Trois-Rivières figure, Hébert's bronze soldier at Yarmouth conveys a truth about the Canadian soldier from 1914 to 1918 that no other memorial artist felt inclined to admit. Every sculptor must have felt some duty to deliver a soldier effigy that was honest and true, yet only Henri Hébert reflected this fundamental and mundane fact about the soldier's life: almost everybody smoked.

Hébert's Yarmouth figure suggests a weary, mud-caked soldier moving to a rest area after an exhausting, fraught time on the front lines. He is bent over, dirty, spent. But he has survived, and he is enjoying a good smoke.

Wartime photographs of men in the trenches make it plain that cigarettes were as commonplace in a soldier's life as lice, rats, and danger. Why would Hébert be the only artist to represent this fact? Even at a time when smoking was nothing like the frowned-upon behaviour it has substantially become in modern times, is it possible that showing a soldier with a smoked-down cigarette stub between his lips was just too undignified? Too inconsistent with the notion that the sculptor was somehow obliged to represent the soldier as possessed of only the best of personal habits, the most upright of values, and the purest of hearts?

Whatever the answer, Henri Hébert chose not to buy in, and by depicting the Canadian soldier as a fellow who smoked—and perhaps cussed, liked his rum, and chased women when opportunity arose—he produced one of the most frank, original and satisfying war memorial figures in the entire country. The Yarmouth soldier is a joy.

TWO WHO KNEW

KENORA, ONTARIO, IS A SMALL city, population about fifteen thousand, in far-flung northwestern Ontario, on the north shore of Lake of the Woods. The hamlet had a more evocative name before it became Kenora in 1905—Rat Portage. In the early years of the twentieth

century, Rat Portage became a hockey powerhouse. Seven local boys grew up to be big-time hockey players, three of them admitted to the Hockey Hall of Fame. Kenora has the distinction of being the smallest city ever to produce a Stanley Cup–winning team, the mighty 1907 Kenora Thistles, four of whose members are hall-of-fame legends.

Kenora's war memorial, situated in a prominent location in the centre of town, is a handsome stepped-granite column. A bronze tablet on the front face of the column offers these words: "For the dead a tribute, for the living a memory, for posterity an emblem and loyalty to the flag of their country."

For what cause did the boys of Kenora fight and die in the Great War of 1914–1918? The same tablet moots an answer: "The citizens of Kenora have erected this monument in grateful remembrance of the services of her sons who upheld the honor and integrity of their beloved country in her hour of peril."

Standing atop the Kenora memorial column is an unusual and striking bronze soldier: an infantryman in winter, dressed for warmth in greatcoat and sheepskin vest. He has minor interest in something to his left but looks taciturn, calm, collected. He is unruffled. Nothing in the presentation suggests flamboyance.

His creator was Charles Adamson (1880–1959), a journalist, sculptor and veteran of the Great War. Having experienced the hard reality of life in the trenches, Adamson was disinclined to glorify war. His Kenora figure is restrained and understated, evoking an ordinary soldier trying stoically to get through another day on the cold, muddy, lethal front lines.

Adamson produced just one war memorial design, but one sufficiently affecting that it was realized three times—on the Sons of England monument at Toronto, at Wingham in Huron County, southwestern Ontario, and at Kenora.

The monument-seeker who goes into Kenora to see Charles Adamson's winter soldier may discover that the lower steps of the war memorial are a congenial gathering place. Some in the assembly may be First Nations people, one of whom may make a friendly approach to the visitor who shows interest in the monument. She may point to one of the names included among Kenora's war dead: M. Land, her grandfather Moses. The granddaughter never knew her grandpa.

137

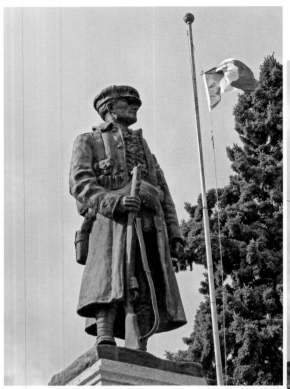

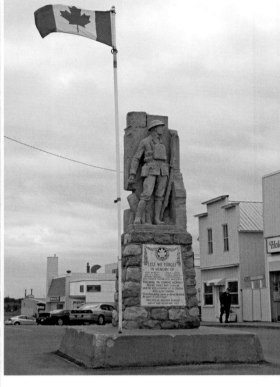

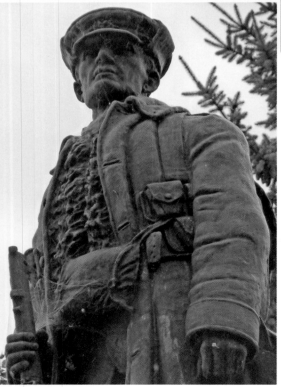

▲ CLOCKWISE FROM TOP LEFT ...
Charles Adamson; Kenora, Ontario

Frank Norbury; Holden, Alberta

Adamson; Kenora, Ontario

Moses Land of Grassy Narrows was a twenty-year-old trapper-hunter when he enlisted in the Canadian Expeditionary Force in June of 1916. Sixteen months later, fighting in the Forty-Fourth Infantry Battalion, he found himself in the hellish quagmire of Passchendaele. On 3 November 1917, Moses breathed his last. His unsentimental death register card records these details: "Died of Wounds. While proceeding to the front line trenches at Passchendaele, he was severely wounded in the abdomen from an enemy shell. His wounds were dressed and he was taken to No. 44 Casualty Clearing Station where he died."

Holden, Alberta, is a northern Prairie village a hundred kilometres east of Edmonton. A water tower stands tall at the foot of Holden's main street; beside it a large sign welcomes visitors to the village and invites them to "share the charms of country living." The main street is named Fiftieth, but don't be misled: in Holden there are only six streets, running from Forty-Eighth to Fifty-Third. Its population is under four hundred, but townsfolk will tell you that one of the village's sons was a luminary: drag racer Dale Armstrong is a member of the Motorsport Hall of Fame.

Given Holden's small size, it is perhaps surprising that the names listed on the front panel of the hamlet's war memorial run to as many as nine who made "the supreme sacrifice" in the Great War. One of those named is John Montague McCloskey, a twenty-four-year-old farmer at the time he enlisted at Edmonton in the Sixty-Sixth Infantry Battalion in November 1916. Close to half of the men who enlisted in the Canadian Expeditionary Force were not native-born Canadians. McCloskey was one of these, a Scot who listed his next of kin as his father, James, of Glasgow.

By April of 1917, Sergeant McCloskey was serving in the Eighth Battalion, Winnipeg Rifles. On April 27, the Eighth Battalion went on the attack in a four-day action that would culminate in the capture of Arleux-en-Gohelle. By the evening of April 29, the battalion's casualty count was seven officers and an estimated three hundred "Other Ranks" killed, wounded, and missing in action. One of those casualties was John McCloskey. His body was never recovered and identified. He is just one among the thousands of Canadian soldiers who lie in the battlefields of France without an identified grave marker. They are all remembered on the great national memorial at Vimy.

Though Holden is tiny and well off the beaten track, it has a remarkable war memorial. As the visitor approaches the centre of the village by way of its broad, main thoroughfare, he sees a monument unlike any other in Canada. The stone soldier that is its focal point conceals himself in the ruin of a shelled-out building. His back is pressed against the remnant of the wall still standing. Vigilant, he looks over his left shoulder. In his right hand is the grenade he is about to hurl into enemy ranks. The effect of the figure is instantly powerful, but rather than a glorification of what is depicted, it is somehow simple, unvarnished reportage: this is what war is all about. Soldiers are about to die.

The Holden monument, one of the best in the country, is the work of Frank Norbury (1871–1965). Norbury had three things in common with Charles Adamson: he was a newspaperman, a sculptor, and a veteran of the Great War. For that last factor, Adamson and Norbury are unique: the only memorial sculptors working in Canada in the years after the Great War who had actually been there, fighting in the trenches beside the soldiers their sculptures are meant to honour.

Is it just a coincidence that neither artist is a glorifier of war? Neither felt impelled to create a monument like the Whitehead figure at Lunenburg or the MacCarthy one at Verdun, in which a triumphant soldier exults in the euphoria of victory, the glory of war.

The Holden monument is magnificent, its power compromised by just one factor. Norbury carved his soldier in Manitoba Tyndall stone, which is just about as soft and perishable as marble. Though its impact is still great, the stone soldier of Holden shows the effects of ninety northern Alberta winters and summers—it is eroded. An admirer standing before the Holden figure thinks, "If only Norbury had rendered it in bronze."

▶ *OPPOSITE, TOP, LEFT AND RIGHT* ... Norbury; Holden, Alberta

▶ *OPPOSITE, BOTTOM* ... Cenotaph, Red Deer, Alberta

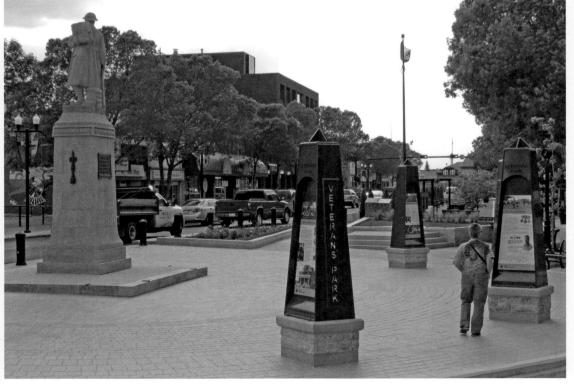

Two hundred kilometres southwest of Holden is another Frank Norbury masterpiece. Red Deer is home to more than 100,000, Alberta's third most populous city. Eight Red Deer lads have reached hockey's pinnacle, the NHL. Townspeople are keen supporters of their Western Hockey League Red Deer Rebels.

The monument-seeker is well rewarded for negotiating Red Deer's downtown traffic in search of the city's cenotaph in centrally located Veterans Park. Here, on a fine granite pedestal, the visitor finds a beautifully rendered Tyndall-stone soldier. Dressed in winter greatcoat and holding a rifle in his right hand, the soldier stands on the "duck boards" that only sometimes kept soldiers' feet out of the mud and mire typical of trench life. Behind his right calf is a stack of sandbags, a familiar, everyday feature of the Western Front. The Red Deer soldier is anything but exultant. Looking over his right shoulder—to home, some observers imagine—he is contemplative, subdued, taciturn.

The dedication of the Red Deer cenotaph went ahead 15 September 1922. A month later, October 28, *Saturday Night* magazine reported on the occasion. Presiding over the ceremony was Julian Byng. Five and a half years earlier, Byng had been commander of the Canadian Corps, the officer who led the Canadians to their great victory at Vimy Ridge. By September of 1922, he had a new role of consequence to Canadians, the country's twelfth Governor General. A huge throng, thousands, attended the Red Deer dedication.

The people of Red Deer did well then, and they continue to do so now. Red Deer's cenotaph is a five-star example of a community excelling at looking after its war memorial. The monument itself is in excellent repair. Though it, too, is carved in Tyndall stone, it is in much happier condition than the Norbury figure at Holden. It has clearly been cared for. The cenotaph's setting—a newly refurbished, broad, cobbled plaza—is also exemplary. Three black obelisks display interpretative panels about Red Deer's military history. The overall effect is compelling. If only Red Deer's example were commonplace across the country.

Norbury's figures at Holden and Red Deer radiate authenticity and verisimilitude. They are the work of an artist who not only knew what the Great War was about, but felt certain about the way in which it ought to be represented.

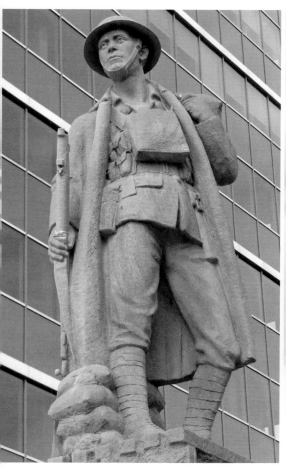
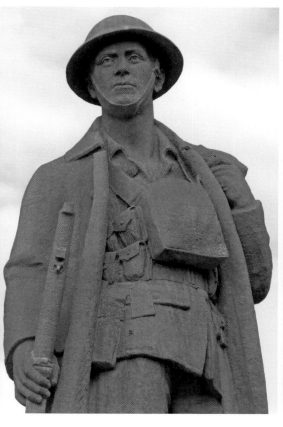

▲ Norbury; Red Deer, Alberta

Between them, Charles Adamson and Frank Norbury produced just three designs for Canadian war memorials. Each of them deserves to be ranked among the very best in the country.

GEORGE W. HILL

HOME TO THE BRONFMANS AND the Molsons, to Brian Mulroney and Marc Garneau, birthplace of Leonard Cohen, Norma Shearer, and Eugenie Bouchard, Westmount, Quebec, is one of the toniest, well-heeled neighbourhoods in all of Canada. A tourist to Westmount is left with the impression that none living there need resort to bottle drives or bake sales to make ends meet. It is the sort of place that in an earlier era might have induced the observant visitor to invoke Browning's famous line from *Pippa Passes*: "God's in His heaven—All's right with the world!"

Such invocation is reinforced at the sight of the community's entirely remarkable war memorial. An impressive granite column is flanked by three lower, ornately carved stones bearing the names of the sons of Westmount who bravely went off to do their bit in the war of 1914–1918 and never returned to the warm embrace of Mother and Father.

On the sides of the main column, skilfully rendered bas-relief panels denote a soldier's comforts: a mother knits socks for her boy-soldier at the Front, a comely young nursing sister attends to a wounded man seated easily in a wheelchair. All's right with the world.

Dominating the monument are the two figures on its crown. A soldier marches briskly and purposefully forward, wearing full military kit, rifle resting on left shoulder. Something distracts him. He looks

144

▶ *OPPOSITE, TOP AND BOTTOM LEFT ...*
George W. Hill; Westmount, Quebec

▶ *OPPOSITE, BOTTOM RIGHT ...* George W. Hill.
Bibliothèque et Archives nationales du Québec,
P1000,S4,D83,PH31

over his shoulder to see the second figure: a beautiful winged angel pointing the way. Where? Out of harm's path? To safety? To a comfortable rest area? To food and drink at the nearest *estaminet*? Or is the angel pointing to a place where he can be assured of finding enemy soldiers with whom he can do glorious battle? Everything about the grouping suggests there is no doubt—the latter destination is the one intended.

God's heavenly angel at Westmount has chosen sides: the side of the righteous and virtuous "Men of Westmount who gave their lives in the Great War of MCMXIV–MCMXVIII." One is left to wonder what heaven and which angel blesses the enemy soldiers facing their Canadian foes; each German adversary wears a belt buckle inscribed *Gott mit uns*—God with us.

The Westmount monument is instantly, obviously the work of a highly skilled, talented artist working at the peak of his form. The artist is George William Hill (1862–1934), age sixty when he completed the Westmount figures in 1922, a mature maestro at the top of his game.

To today's sensibilities, it may seem quaint that one side of a great conflict could be portrayed as being entirely on the side of the angels and the other entirely not. But the notion was not nearly so strange in 1915 or 1925. Monumental angels evoked at least two important views comforting communities and individuals across the country.

One was the opinion that the part Britain and her dominions played in the war was not simply just, virtuous, and righteous, but "To the Glory of God"—a conviction explicitly stated on many war memorials across the country. The other widely held idea was an intimation of immortality: the soldier who made "the ultimate sacrifice" in the righteous war had not died but had secured a place with the angels in the firmament of heaven.

Born in Quebec's Eastern Townships region, Hill built some of his expertise at the knee of his father, a stone-carver. He refined himself as a sculptor through study at two Paris institutions in the early 1890s. He was a member of the Royal Canadian Academy.

Based at Montreal, Hill produced several public monuments to famous Canadian nation builders—D'Arcy McGee, George Brown, and George-Étienne Cartier—but it was as a war memorial sculptor that George Hill made his greatest mark. No artist realized more designs

on Canada's war memorials than Hill. Two are glorious tributes to the Canadian heroes who fought in the South African War of 1899–1902. Many of Hill's memorial figures are in Quebec, but Ontario has several, and there are three in Nova Scotia and Prince Edward Island.

The Westmount work is not the only Hill monument representing angels as being on the Canadian soldier's side in 1914–1918. At Sherbrooke, Quebec, there is another construction that is even more grandiose than Westmount's. In Sherbrooke, a principal thoroughfare, King Street, ascends to a height of land overlooking the entire city. In its median there is an impressive stepped pedestal in Stanstead granite. On the lower step, not one but three Canadian soldiers place their fate in the hands of a supporting angel. The angel stands high, though lightly, on the higher column, just one foot touched down, wings outstretched. She is a creature of the ether, not the earth.

Grasping a wreath in her right hand, the angel holds her left over the soldiers' heads, as in benediction. All three soldiers' faces are turned up, the men looking rapturously at their guardian. They have eyes for their angel and her alone.

Hill's Sherbrooke grouping is a very grand piece of work. What significance can we deduce it held for the people of Sherbrooke at the time it was conceived and created? The main inscription gives one clue: "To the men and women of Sherbrooke who fought and fell for their Country and their God." Their Country and their God.

There are other signs. Soon after the war, the city, whose population was 39,000 in 1921, determined that its monument had to be magnificent; after all, 248 townspeople had died in the war. Sherbrooke earmarked some $25,000 for the endeavour, more than a third of a million in today's dollars. Sherbrooke initiated a competition to determine who would create it. Hill won.

The completed monument was dedicated 7 November 1926. An enormous throng gathered for the occasion; there was insufficient space to accommodate everyone. Younger, fitter citizens climbed trees or clambered to the roofs of buildings. Some even managed to scale the bell tower of the Church of St. Patrick. Some counts put the assembled crowd at twenty thousand, about half the population of the entire city. Such was the importance of Canadian war remembrance in the 1920s.

Westmount and Sherbrooke represent only two-thirds of George Hill's angelic oeuvre. Pictou, Nova Scotia, is famed as the landing place of the first boatload of Scottish immigrants to New Scotland; 189 arrived on the ship *Hector* in 1773. Here, on a slope at slingshot distance from the *Hector's* landing place, the monument-seeker finds another grandly stated George Hill vision.

The Pictou group is a celebration. A returning soldier, helmetless but still carrying his rifle, is greeted by the figures of a boy and a woman. The rhapsodic boy lifts both hands to the soldier's face. The woman holds a wreath over the soldier's head. Is she another angel or a representative of proud Canadian womanhood? Whichever, in her right hand she cradles a balance scale: the soldier has submitted himself to the tests of manhood imposed by the trials of the trenches and has not just passed but triumphed. He has come through. Not merely a survivor, he is a hero.

Look assiduously through the entire Hill canon; one finds not a single war memorial figure that is anything but heroic. Not one of Hill's memorial bronzes hints that the Canadian soldier might ever have had a moment of faint-heartedness or fear. There is no notion that a Canadian ever went "over the top" feeling trepidation or abject terror.

Three Hill figures—at Magog and Lachute, Quebec, and Morrisburg, Ontario—all pay homage to the Bernard Partridge doctrine of war commemoration. Hill's Magog figure extends particularly faithful tribute to the famous Partridge illustration *Punch* magazine published in the aftermath of the Canadian victory at Second Ypres in April 1915. At Magog, there is indeed only one significant departure from the Partridge original: rather than a helmet, it is a grenade the exultant Canadian raises high in celebration.

149

◄ *OPPOSITE* ... George W. Hill; Sherbrooke, Quebec

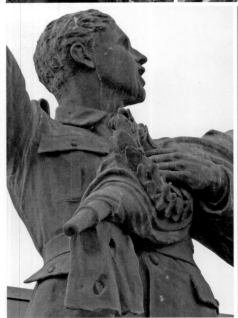
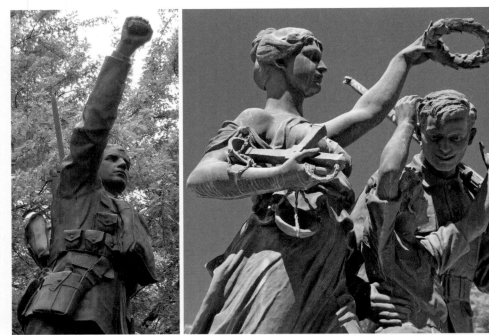
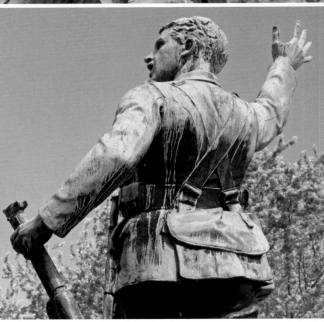

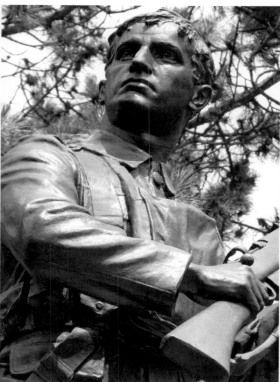

At Morrisburg, the triumphant Canadian's right hand is empty, but his left hand cradles a wreath and a staff-mounted battle flag. The flag is rent by . . . bullet holes. The soldier is in mid-shout: Glory to the victorious Canadians!

The Lachute work is a close variation; again the soldier exults, right hand raised in glory, but rather than a shot-through battle flag, it is the soldier's trusty Lee-Enfield rifle he clutches in the opposite hand.

Every Hill monument is masterly, a technical marvel, but none of them is subtle. The Alfred Howell figures at Sault Ste. Marie and Guelph, and the Walter Allward ones at Peterborough and Stratford, may not be especially subtle either, but their intent is not instantly obvious. Hill soldier sculptures are otherwise; not for a moment do they leave the observer scratching his head and wondering, what does this mean?

At Harbord Collegiate in Toronto there is yet another George Hill soldier in bronze. Though not quite so triumphant as his comrades at Magog, Lachute, and Morrisburg, the Harbord figure is no less heroic. This soldier is helmetless and intrepid. Head turned to his left, rifle grasped in both hands, he looks intent. There is no apprehension in his gaze, only determination. This Canadian "Tommy" is looking for the enemy. And he intends to find him.

The same can be said for the solitary soldier George Hill produced for the community of Richmond, Quebec. Rifle in hand, the soldier marches briskly forward. He is all manliness—resolute, determined, utterly focused. This man is going into action; he is bound for glory.

One more George Hill conception is saved for last: his monumental masterpiece at Charlottetown, Prince Edward Island. In front of Province House, the Island's 1847 House of Assembly, where the Fathers of Confederation gathered in 1864 to invent Canada, three stalwart

▶ *OPPOSITE* ... Hill; Charlottetown, Prince Edward Island

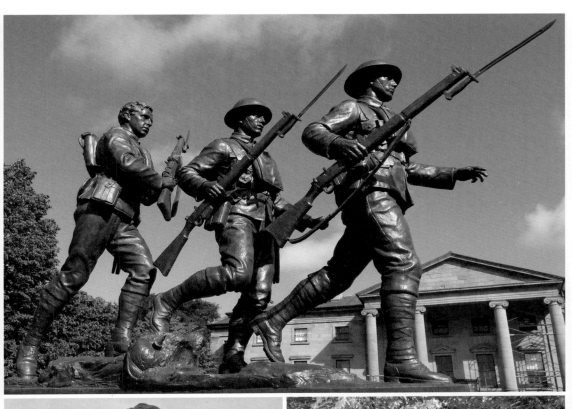

soldiers march smartly toward the enemy. The lead man is familiar—he is the same figure seen at Richmond. They all carry rifles, bayonets mounted. Two are helmeted. The fearless third heads into action bareheaded. What need has he for a helmet?

They march through a churned battlefield. Among the trampled debris under their boots is a German pickelhaube helmet. This is an augury of what is in store for the trembling Germans about to face these terrifying Canadians.

The Charlottetown grouping is Hill's crowning glory. The Charlottetown men need no angels: they are ready, willing, and able to deliver the country's expectations without help from a higher power. No divine intervention is necessary; these Canadians can do it alone.

George Hill was the artist of choice for those who preferred that the Canadian soldier of the Great War should be represented as courageous, fearless, unconquerable. For those communities seeking to have their brave lads depicted as the shock troops of the British Army, it was absolutely the right choice to turn to George Hill.

But there is this: not everyone saw a Hill monument as the *sine qua non* of memorial statuary. Not every community sought to memorialize its fallen by a monument conveying the sort of message assured by a George Hill figure.

EMANUEL HAHN

WESTVILLE, NOVA SCOTIA, IS COAL country. Local men began moiling for "black gold" in the 1860s, and mining continued for more than a century. By the Second World War, three mines operated at Westville. In the downtown core, a monument—one of the oldest in Nova Scotia—speaks to a consequence of coal mining. The old monument commemorates the 1873 explosion and fire at the Drummond Mine and lists the names of those killed outright or forever sealed underground in the mine. Seventy men died in the catastrophe. It would not be the last coal-mining disaster to strike the miners of Westville.

There is another noteworthy monument at Westville. It stands beside the town post office and lists the names of the men of Westville

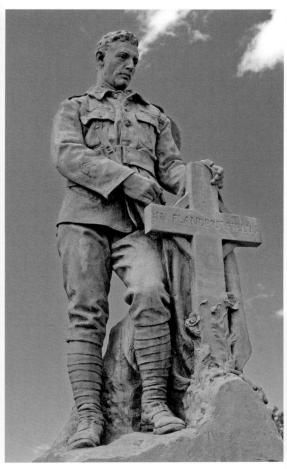

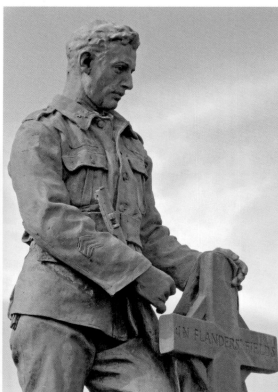

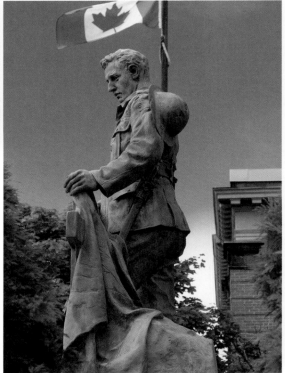

▲ Emanuel Hahn; Westville, Nova Scotia

who died in the Great War of 1914–1918. Standing on top of the central granite column is a soldier in bronze. The soldier is bareheaded, helmet slung over his shoulder, rifle at his side. His head is slightly downturned. His left hand rests on the top of a waist-high cross, a battlefield grave marker. The soldier is at the "final resting place" of a fallen comrade somewhere in Flanders. His grief is registered with a minimum of licence. He is contemplative, quiet, sombre.

The Westville figure brings to mind the familiar words the soldier-poet Wilfred Owen drafted for the preface of a book of war poems he planned to publish in 1919:

> This book is not about heroes. English poetry is not yet fit to speak of them.
> Nor is it about deeds, or lands, nor anything about glory, honour, might, majesty, dominion, or power, except War.
> Above all I am not concerned with Poetry.
> My subject is War, and the pity of War.

Owen never saw his book published. He was killed in action in November 1918, just a week to go before the Armistice.

The pity of war, not its glory.

At the base of the Westville monument one finds this mark: *E. Hahn Sc. 1921.* The Westville bronze is the work of a sculptor named Emanuel Hahn. It turns out that, for reasons we will come to in this chapter, the Westville figure is the only one among Hahn's many war monuments that was signed by the artist.

Emanuel Hahn (1881–1957) was seven years of age when he immigrated to Canada with his German family in 1888. The Hahns were a talented tribe. As Emanuel was growing up to become a highly regarded sculptor, his older brothers distinguished themselves too— Gustav as a painter, Paul as a cellist.

Hahn studied art and design in Toronto before returning to Germany for additional training at a Stuttgart art academy, and he apprenticed for a time with a sculptor teaching at the academy. Back in Canada, he worked as assistant to sculptor Walter Allward, the artist who designed Canada's national war memorial at Vimy Ridge.

Hahn was co-founder and first president of the Sculptors Society of Canada.

In the fullness of time, Emanuel Hahn would produce a broad portfolio of public sculpture. His subjects range from the great Scots poet Robert Burns to the legendary Ontario rower Ned Hanlan. Look to the loose change in your pocket to see other examples of Emanuel Hahn design: the *Bluenose* on the Canadian dime and caribou on the quarter are Emanuel Hahn designs, as are the *deux voyageurs* of the fondly remembered silver dollar.

In his earlier years, Hahn worked as a designer with the McIntosh Granite Company of Toronto. By the end of the war, he had moved to a Toronto competitor, the Thomson Monument Company. Hahn was Thomson's chief designer by 1919, when communities across Canada began asking the Thomson people to help build monuments to commemorate their sons and daughters who had gone off to war and never returned home.

At a place in far southwestern Ontario, then called Black Creek, one James Miller Williams dug a well for water in 1858 but struck oil instead. Black Creek thus became Oil Springs and, for a time, was an oil boom town. It is to Oil Springs one travels to see the war memorial featuring the first Emanuel Hahn sculpture evoking the Canadian soldier of the Great War. It was completed and installed in 1919, just a year after the Armistice.

Having for a time collaborated with Walter Allward, it is perhaps not surprising to see shades of allegory and symbol in Hahn's early Oil Springs figure. The sculptor called his work *Fetters Sundered*. The figure is a young man wearing not a soldier's uniform but hardly anything at all. In his upraised left hand he holds a fragment of chain and in his right a broken sword. The figure celebrates that war is ended, its shackles and weapons demolished. Below the young man are listed the names of the seventeen fallen sons of Oil Springs who died "for Liberty and Peace."

Hahn figures in the same or similar vein are found on war memorials at nearby Alvinston, Ontario, and at Malvern Collegiate in Toronto. The Malvern figure was in the news in 2011 when, freshly refurbished through a $44,000 community restoration effort, the monument was

157

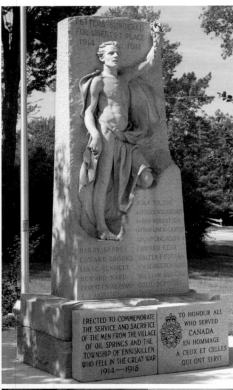

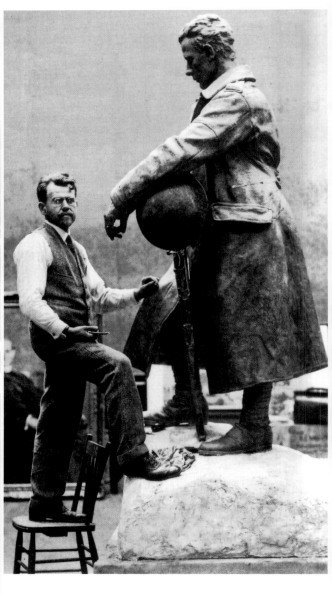

▲ CLOCKWISE FROM TOP LEFT ...
Hahn; Oil Springs, Ontario

Emanuel Hahn, at work on *Tommy in Greatcoat*.
Provided by and used with permission of the
family of Emanuel Hahn

Hahn; Malvern Collegiate, Toronto, Ontario

almost immediately attacked and damaged by vandals. The damage was undone, then in 2014 the Malvern monument was vandalized and damaged again.

At the community war memorial in Summerside, Prince Edward Island, the monument-seeker finds another Emanuel Hahn soldier, one in bronze. To date, vandals have seen fit to do it no harm. Summerside is just sixty kilometres from Charlottetown, where George Hill's trio of Canadian "Tommies" march eagerly into action against the enemy. While the distance between Summerside and Charlottetown may be short, the gulf between the two monuments is anything but.

Hahn's Summerside figure requires no allegorical interpretation. It depicts a soldier going into action. He is in full stride, running. The left arm is extended; the right hand grasps a rifle. The look on the soldier's face conveys something quite unlike the cocksure confidence Hill depicts at Charlottetown.

What did an ordinary soldier feel at zero hour in his trench when, at an officer's whistled signal, he went over the top and into action, running headlong into massed German machine guns? Was it exultation that seized his heart? Euphoria? Joy? Or was it something quite different? Apprehension? Fear? Outright terror? George Hill posits one answer at Charlottetown; Emanuel Hahn suggests another at Summerside.

Canada's greatest homegrown general officer of the 1914–1918 war, the man who commanded the Canadian Corps through all its successes in the last year and a half of the war, was Sir Arthur Currie. After the war, he found a new role, one he loved, as principal of McGill College in Montreal.

Directly across the St. Lawrence River from Montreal is the community of Saint-Lambert. Sir Arthur decided to sponsor the Saint-Lambert war memorial and underwrite its costs. On the issue of what sort of monument to erect at Saint-Lambert, Currie felt it should represent the men of the Canadian Corps, men for whom he felt enduring esteem and affection. When the time came to determine which artist and what figure should be chosen, Sir Arthur decided the artist should be Emanuel Hahn and the design the same as at Summerside. And that is what happened. In all Canada, the Summerside design occurs only there, and at Saint-Lambert. Nowhere else.

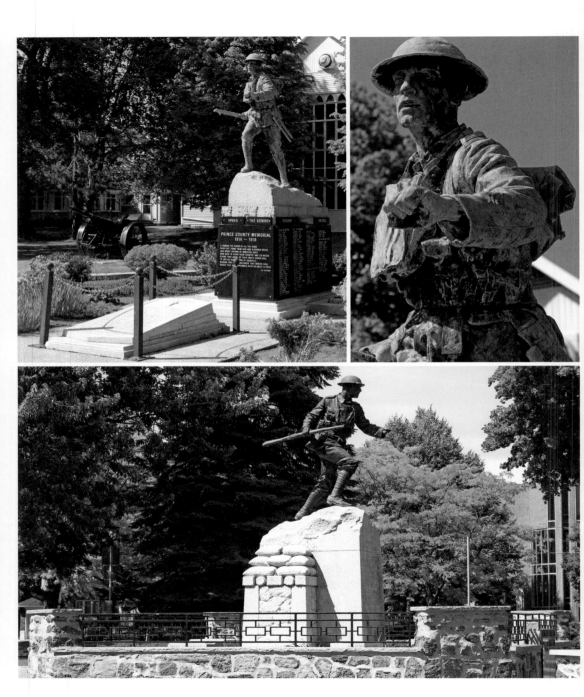

◄ OPPOSITE, CLOCKWISE FROM TOP LEFT ...
 Hahn; Summerside, Prince Edward Island

 Hahn; Summerside, PEI

 Hahn; Saint-Lambert, Quebec

▲ CLOCKWISE FROM TOP LEFT ...
 Hahn; Lindsay, Ontario

 Hahn; Saint-Lambert, Quebec

 Hahn; Lindsay, Ontario

Sir Sam Hughes was Canada's Jekyll-and-Hyde Minister of Militia. In 1914, Hughes did a masterful job of organizing the Canadian Expeditionary Force, then spent much of the war belligerently antagonizing just about everyone who crossed his path. Initially a supporter of Currie, he eventually became Sir Arthur's tireless tormentor. At Lindsay, Ontario, Sir Sam's hometown, Hughes arranged to have himself listed among the community's war dead, despite the fact that he was neither fallen nor a soldier in the CEF.

Standing above the list of war dead on the Lindsay war memorial there is another Emanuel Hahn bronze soldier, *Tommy in Greatcoat*. It is cut from the same muted bolt as seen at Westville and Summerside. The Lindsay figure depicts a soldier in winter greatcoat. His head bent downward, the soldier rests on his rifle, helmet hanging from his left forearm. He is an essay in pensive, quiet contemplation. What is he thinking about? An answer is easy to imagine.

It is often claimed by the inscriptions seen on war memorials that Canadian soldiers paid the ultimate sacrifice "for King and Empire," or for such ethereal values as Justice, Freedom, and Civilization. But read the testimony of soldiers themselves, and one finds, time and time again, that the soldier's real loyalty was to neither king nor empire but to the band of brothers with whom he went into battle and with whom he struggled daily merely to survive.

Soldiers' fear of death was typically surpassed by another apprehension—the dread that they might let the side down and through faint-heartedness or cowardice shame themselves in the eyes of the men of their own platoon. It is to his immediate comrades-in-arms that the soldier typically felt the strongest tie, the most compelling duty and the greatest loyalty. Read the war memoirs of soldiers: when a man lost a beloved brother-in-arms to an enemy shell blast, piece of shrapnel, or burst of Maxim machine-gun fire, the effect was devastating.

In this context, it is easy to imagine what Tommy-in-greatcoat is contemplating at Lindsay, and also at Moncton, New Brunswick, the

▶ *OPPOSITE* ... Hahn; Moncton, New Brunswick

only other place in the country where Emanuel Hahn's Lindsay figure is the focal point of a community war memorial.

What was the community response when these Hahn figures were unveiled? It is not all that difficult to deduce an answer. If a monument aficionado happens to feel that the Westville bronze is the finest community war memorial figure in the country, he needn't work hard to find evidence that many others have felt the same way.

In 1920, not yet forty years of age, Emanuel Hahn was a well-established, highly regarded sculptor. A community wishing to have a Hahn soldier of its own for its new war memorial had to be prepared to invest considerably more than it would for an anonymous Carrara marble. But despite cost considerations, that is precisely what happened. First one, then another, then yet another community decided that nothing would do but to have the same soldier as first appeared at Westville in 1921. Eventually the total supplied by the people at Thomson would be ten, and Hahn's grieving soldier would be found across the country, from Westville, Nova Scotia, to Fernie, British Columbia.

After Westville, only one other—at Cornwall, Ontario—would be cast in bronze from Hahn's original. The other eight supplied by the Thomson Company would be in granite, carved by Thomson's master craftsmen to the same scale and the same Hahn design. This is not to say they are all identical. Each was carved individually; each shows subtle differences from the others.

Because they are in granite rather than much softer marble, Hahn's stone figures are much better preserved than many of the Carrara marbles we have seen. A survey of these figures is instructive and reveals much about variability in the standards present-day communities apply to the preservation of their monuments.

For the most part, towns having a Hahn figure on their war memorial have invested the effort required to keep it in a fair facsimile of its original condition. The current state of these monuments conveys the impression that communities still bring pride and protectiveness to the task of keeping them whole. But there are variations.

While more durable than marble, granite is not impervious to the elements. Consider the difference between the figures at Fort William and Petrolia, Ontario. The granite soldier at Fort William—now Thunder

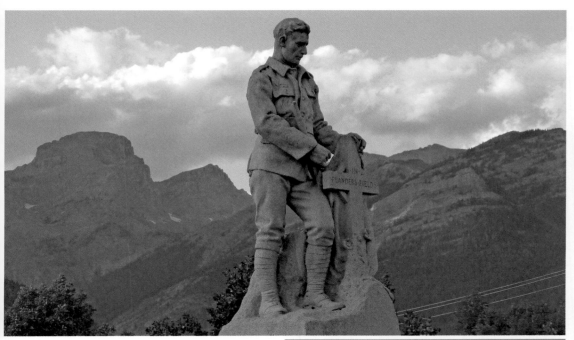

▲ *ABOVE* ... Hahn; Fernie, British Columbia

▶ *RIGHT* ... Hahn; Fort William (Thunder Bay), Ontario

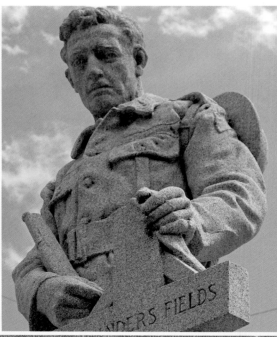
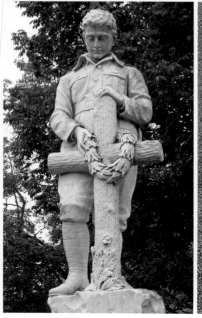

History

This monument was unveiled on June 22, 1922, in the presence of about 2000 people from the surrounding district. The monument was erected to the memory of those from the town of Russell, village of Binscarth, and the rural municipalities of Russell, Boulton, Silver Creek, and Shellmouth who laid down their lives in the Great War (1914 - 1918).

Plaques donated by the Ladies' Auxiliary to the Royal Canadian Legion Branch #159 commemorating the Second World War dead, were placed and dedicated on November 11, 1980.

Vandals removed the head of the statue on Halloween of 1999. The community was outraged at the thoughtless disrespect of the act. The head was recovered and reattached and the intersection refurbished.

This monument to our gallant heroes was rededicated during the Millenium.

Bay—has been looked after; it is clean and uncorrupted. By contrast, in 2012, the features of the Petrolia figure were very nearly indiscernible, hidden behind a mask of lichen. Fortunately, given appropriate attention, the Petrolia figure could be restored at no great cost.

Sometimes the preservation issues that arise are extraordinary. On 1 November 1999, the morning after Halloween, the people of Russell, Manitoba, awoke to find their Hahn soldier decapitated. Fortuitously, while citizens' opinions of their fellow man perhaps took longer to repair, the soldier's head was soon recovered and the figure restored.

For communities not having the resources to acquire their own authentic Hahn grieving soldier, there was a cost-effective alternative: provide a detailed photograph of the Westville original to the stone-carvers of Carrara and ask them to make a copy in marble. Such copies are widely distributed in Canada, from Springhill, Nova Scotia, to Killarney, Manitoba, to Unity, Saskatchewan. More can be found at Wolseley, Saskatchewan, and at Seaforth, Teeswater, and Port Dalhousie, all in Ontario.

The imitations are not all equally well executed, and not every carver felt obliged to pay slavish homage to the Hahn original. In some cases, the Italian craftsman decided to supply an individual flourish distinguishing his impersonation from the others. At Priceville, Ontario, the field grave marker is represented as made not of milled lumber but tree sections still sheathed in bark—and a wreath rings the marker for good measure.

The Unity model is especially attractive, though when seen "in the flesh" for the first time, the monument-seeker is surprised to discover that this soldier is a bantam, barely four and a half feet tall.

167

The Killarney figure is a particularly faithful copy of Hahn's original, and so is the one at Springhill. Indeed, when seen for the first time, the Springhill figure gives the impression that it actually is an authentic Thomson-supplied iteration of Hahn's design. But it is not: Thomson furnished its stone soldiers in granite; the excellent Springhill copy is Italian marble.

Still other monumental soldiers, not Italian copies, but figures made in Canada and supplied by Thomson competitors—such as those at St. Stephen, New Brunswick, and Barrie, Ontario—have clearly been influenced by Hahn's Westville original.

Thomson competitors were not above employing underhanded tactics to win a commission. Recall that the original at Westville is the only Hahn figure in the entire portfolio that bears the sculptor's mark. Other prominent sculptors—George W. Hill, Coeur de Lion MacCarthy—typically emblazoned their names along an entire side of a monument base. Why would Hahn not do likewise?

The answer lies in Emanuel Hahn's origins: he was born in Germany. He had come to Canada as a young boy and had become a Canadian citizen on the first day he was eligible to do so. But Hahn was German-born, and Canada had just been at war with Germany. Thousands of young Canadians had been killed by German artillery, German machine guns, German poison gas, German torpedoes. To secure a commission, Thomson competitors sometimes took pains to mention that their designers were Canadian-born, while the Thomson designer was a German native.

The story of the Winnipeg cenotaph shows how effective the insinuations could be. In the early 1920s, the City of Winnipeg launched a juried competition to select a design for the city's cenotaph. A panel of experts was struck to make a blind selection of the submission judged to be the best.

The panel's selection was unanimous. When the successful design was made public, even those whose submissions had been rejected were largely agreed—the chosen design stood above the others. The winning proposal was Emanuel Hahn's. He was awarded the commission. Then, over a period of time, an insurrection slowly took shape.

Someone wondered about the name Hahn. When it was confirmed that the artist was German-born, various interest groups, spearheaded

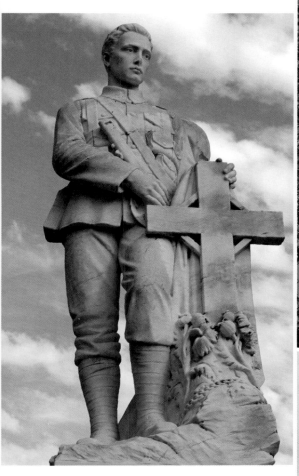

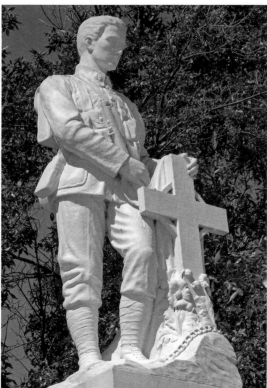

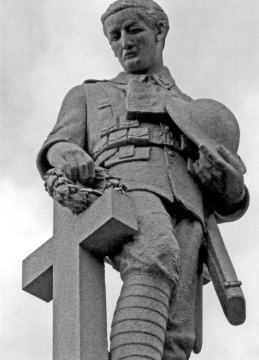

▲ CLOCKWISE FROM TOP LEFT ...
Unity, Saskatchewan

Killarney, Manitoba

Barrie, Ontario

by veterans' organizations, took aim at the city's decision—and at Emanuel Hahn. Some veterans said that if Winnipeg went ahead with Hahn's design, they would spit on the new cenotaph. The battle was joined. Hahn had his defenders, ones who felt the uproar was a disgrace. The supporters did not easily wilt, but in the result, those who brayed loudest won the day: Hahn's commission was cancelled.

Another competition was launched. This time, the ground rules were different: only submissions from those who had been born in Canada or in an Allied nation would be considered. Again an expert panel was struck. Again the experts were drawn to one particular submission. The city awarded the commission to a woman, Canadian-born artist Elizabeth Wyn Wood. Then, for a second time, a storm of protest arose.

It came to light that Wyn Wood had been trained by Emanuel Hahn. And furthermore, by this time, she was in fact Mrs. Emanuel Hahn. For a second time, the battle was joined. For a second time, those who shouted loudest won the debate. For a second time, the awarded commission was withdrawn. Neither Hahn nor Wyn Wood would be permitted to design the Winnipeg cenotaph.

Beaten into submission, the City of Winnipeg did not proceed with a third competition. Instead it awarded the commission to someone who had been a second or third runner-up the first time. The unremarkable cenotaph around which Winnipeggers gather every Remembrance Day is a tribute not just to the men and women of Winnipeg who died in the Great War but also to the venom and hatred the war had spawned in the hearts of Canadians.

In contrast to Charles Adamson and Frank Norbury, Emanuel Hahn had not served as a soldier of the Great War. He had never spent a November night shivering in a muddy trench or endured the terror of an enemy artillery barrage. Yet somehow he managed to convey—at Westville, Summerside, and Lindsay—that he understood what it must

▸ *OPPOSITE* ... Cenotaph, Winnipeg, Manitoba

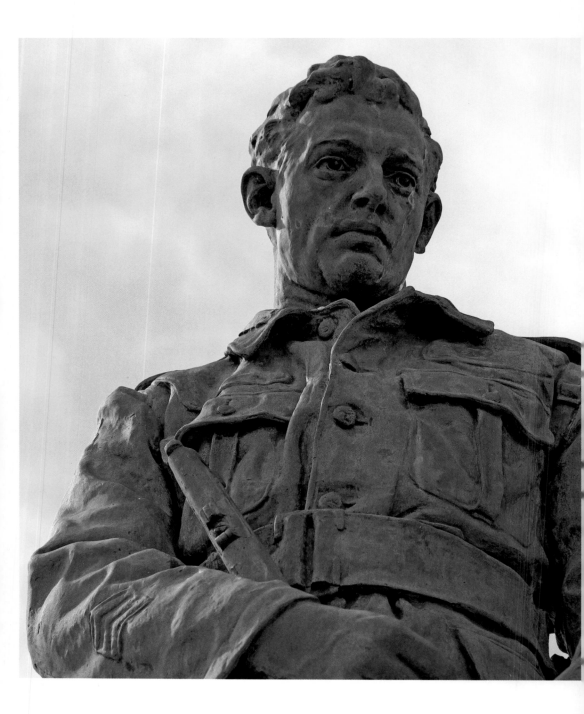

have been like to be there, in the trenches, facing battle, dealing with the loss of a beloved fellow soldier.

One of the great Canadian memoirs of the war of 1914–1918 is Will R. Bird's *And We Go On*. Bird knew all about shivering in trenches and battle terror and the loss of cherished comrades. Bird fought the war and lived to tell about it. Toward the end of his remarkable book, as the troopship carrying him back to Canada is approaching the Atlantic coast, Bird stands at the ship's rail in the dead of night, looking for the first lights of home. He thinks about what he has endured and what he has lost:

> *Prisoners! We were prisoners who could never escape. I had been trying to imagine how I would express my feelings when I got home, and now I knew I never could, none of us could. We could no more make ourselves articulate than could those who would not return; we were in a world apart, in chains that would never loosen till death freed us.*
>
> *And I knew those at home would never understand. They would be impatient, wondering why we were so dumb, unable to put our experiences into words; and there would be many of the boys who would be surly, taciturn, moody, resenting good intentions, perhaps taking to hard liquor and aimless drifting. We, of the brotherhood, could understand the soldier, but never explain him. All of us would remain a separate, definite people as if branded by a monstrous despotism.*

Bird was right of course: those at home would never understand. But perhaps, just perhaps, here or there, the returned soldier might find an exception—someone who did. ⧂

173

THEIR NAME
LIVETH FOR
EVERMORE

IN MEMORY
OF
THOSE WHO GAVE
THEIR LIVES
IN THE SERVICE
OF
OUR COUNTRY

V

*W*HITHER *G*OEST?

ALL THE SOLDIERS OF THE Great War of 1914–1918 are gone. There is no one left who experienced the horror of Western Front trench warfare who can tell us at first-hand what it was like. There is no one left with whom we can talk about the war, no one to hear our questions and appall us with their answers.

All the mothers and fathers who sent their sons and daughters off to war are gone too, and probably all of the siblings who remembered saying farewell to a beloved Flanders-bound brother in 1915 or 1916. There is no one among those moved by unspeakable grief to build community war memorials right across Canada with whom we can sit down for conversation and a cup of tea.

We cannot ask them to tell us about the welter of feeling that overwhelmed them at the news that a beloved son or brother—or perhaps two or even three—had fallen somewhere in France or Belgium. We cannot ask them to tell us about the young person lost. What was he

like? What did he care about? What charmed you most about him? Did he make you laugh?

We cannot ask them to describe the groundswell of emotion that brought whole communities together in determined, wholehearted co-operation to build fine monuments to young people who went off to war and never returned.

Still among us are the sons and daughters of Great War soldiers, nieces and nephews too. Those still living are in their nineties now. Soon they too will be gone. Those two generations removed from the Great War—granddaughters and great-nephews of the soldiers—are themselves approaching their senior years, or are already there.

It is often claimed that though a person may be gone, in a way he lives beyond his mortal span as long as he is remembered by someone still living—especially if memory is warmed by something like love.

But soon enough there will be no living memory of any of the soldiers of the 1914–1918 war. What happens then?

How does one "remember" a person he never knew?

Like memory, stone too fades and withers with the decades. The white-stone soldiers of the nation's community war memorials, so glorious when unveiled in 1921 or 1922, are now crumbling, some faster than others. They are crumbling in the face of weather, acid rain, neglect and—most sadly—by intentional abuse.

How do we comprehend a youth who vandalizes a community war memorial when we know that the youth may well be the great-great-grandson of one of the community leaders who led the effort to build the monument in the first place?

How can we expect that those who are three, four, and five generations removed from the universe of grief that produced these

▶ *OPPOSITE, CLOCKWISE FROM TOP ...*
Tomb of the Unknown Soldier, National Cenotaph, Ottawa, Ontario

Unknown Soldier, Golden, British Columbia

Cenotaph, Reston, Manitoba

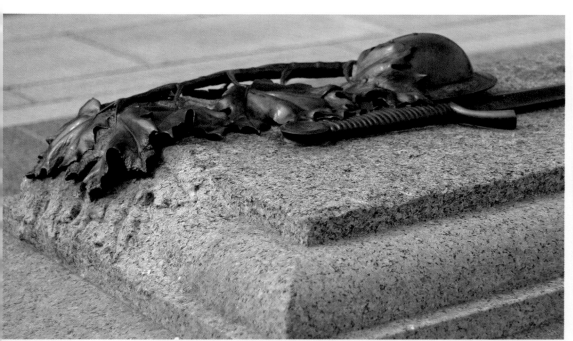

THEIR NAMES LIVETH FOR EVERMORE

ERECTED TO THE MEMORY
OF THE
SOLDIERS
WHO DIED IN THE GREAT WAR
1914 – 1918

THE SOMME
SANCTUARY WOOD
COURCELETTE

memorials will feel the slightest allegiance to the emotions and values felt by their antecedents in the 1920s?

By the year 2065, who will care?

The great-nephew of a soldier who endured the nightmare of trench warfare may be moved by cherished memory to think fondly of his great-uncle when he attends Remembrance Day ceremonies. He may invest effort in building an archive of photographs of his uncle and sharing his archive through the Internet. Inspired by his uncle, he may even go to the trouble of criss-crossing the country to study war memorials and write a book about them. But what happens to the memory of the uncle when the nephew too is gone?

Positive answers to these questions do not leap to mind. Is it enough to set aside the questions, make do with what we have today, and let the Canada of 2065 look after itself?

War memorials are significant in direct proportion to the extent that people still care about them and, more to the point, still care about the fallen soldiers they are meant to honour.

For what did the soldiers die? In the 1920s, community war memorials across the country offered different answers. At Malpeque, Prince Edward Island, the answer was Home, Empire, and Freedom. At Rockwood, Ontario: Liberty, Justice, and Peace. At Harbord Collegiate in Toronto: simply Humanity. At Russell, Manitoba: God and Country. The answer implied by the symbolic figures at Stratford and Peterborough is that the 1914 contest pitted German barbarism against British civilization.

Could it be true that by 1914 the land of Mozart and Beethoven, Goethe and Nietzsche, Mann and Hesse, Einstein and Planck was

FOR·THE·CAUSE·OF
LIBERTY·JUSTICE
·&·PEACE·

ERECTED BY
THE
MUNICIPALITY
OF GEORGETOWN
IN MEMORY OF
THOSE WHO
FELL IN THE
GREAT WAR.
1914-1918.

▲ *ABOVE* ... Cenotaph, Rockwood, Ontario

◀ *LEFT* ... Cenotaph, Georgetown, Ontario

nothing but a barbarian miasma? Prevailing attitudes at the time of the war suggest strongly that the Canadian answer was yes.

During the war, cartoons in Canada's *Saturday Night* magazine incessantly vilified Germans and German civilization. One showed German *Kultur* as expressed in poison gas and liquid fire. Another depicted a "Hun" soldier as standing over the corpse of a young girl he has just shot for waving a toy French flag. In yet another, a giant octopus with the head of a German soldier—complete with pickelhaube helmet—envelopes the *Lusitania* in its lethal tentacles.

Attitudes change.

Nowadays, German barbarism is no longer blamed for the 1914–1918 war. Today the finger is more likely to be pointed at vanity, ego, and jealousy on all sides: royal cousins—the kaiser, the tsar, and the king—as well as military leaders and xenophobic politicians spoiling for a fight. For years, both sides had been preparing for war and were armed to the teeth. What were the generals and admirals to do with their vast arsenal if not enjoy a good war?

How can the people of today be expected to have the same feelings about the war as those prevailing in 1915? How can attitudes toward war memorials possibly match those of the 1920s? The answer, surely, is that they cannot.

But perhaps it is somewhat remarkable that there are people who still do care—people like the unknown Samaritan who so assiduously looks after the war memorial at tiny Margaret, Manitoba. Or the concerned citizens of communities that are investing significant effort and resources in the preservation and restoration of their war memorials, communities such as Lacombe and Red Deer, Alberta; Westville, Nova Scotia; Westmount, Quebec; Georgetown and Thessalon, Ontario.

181

Occasionally we hear about motivated schoolteachers who inspire tenth-graders to care about the war and the Canadian lads who died in its battlefields. Sometimes students "adopt" a fallen soldier, learn whatever they can about him, and share their findings with classmates. For this we can rejoice.

We can celebrate that some Canadians, considerable numbers of them, still care about their history. The place names Ypres, the Somme, Vimy, and Passchendaele still resonate. It is often claimed that Canada

PASSCHENDAELE

THEY SHALL NOT GROW OLD, AS WE THAT ARE
LEFT GROW OLD:
AGE SHALL NOT WEARY THEM, NOR THE YEARS
CONDEMN.
AT THE GOING DOWN OF THE SUN AND IN
THE MORNING
WE WILL REMEMBER THEM."

▲ Cenotaph, Watford, Ontario

came of age as a consequence of its contributions in the Great War, that the nation was forged in the fire of the Western Front. More than a few of us believe it is just so. Many of us believe that the men and women of the war era were a Great Generation.

In a nation of just eight million, nearly two-thirds of a million served in the 1914–1918 war. Between 2002 and 2011, 158 Canadians died in Afghanistan, a number that justifiably distressed us all. The body count in the Great War was greater than sixty thousand.

We are the culmination of our history. As long as history matters, as long as duty, bravery, selflessness, and valour are valued, perhaps those of us who care can hope that the Great War will continue to matter. That war memorials will matter. That the thousands of names on community war memorials will matter. Perhaps we can feel some confidence that the promise inscribed on these monuments will continue to matter:

We will remember them. ⬯

183

\mathscr{A}CKNOWLEDGEMENTS

IN MARCH OF 2014, I gave an illustrated talk on the subject of this book to the annual seminar of the Western Front Association—Pacific Coast Branch. At the conclusion of this talk, Sidney Allinson sprang to his feet, commended the presentation, and insisted that I simply *had* to write a book on the subject. Sidney was the first and one of the most enthusiastic boosters of the project you now hold in your hands. When, more than a year later, I completed *Remembered in Bronze and Stone*, it was Sidney I first informed of the project's completion, and it was to Sidney I first turned when the time came to invite others to read the manuscript. His response to the finished product was every bit as enthusiastic as his initial reaction to the talk had been the previous year. I am very grateful to Sidney for all that enthusiasm and for the significant impetus he gave to this project.

Four other members of the Western Front Association have also been generous in their encouragement and their time and attention paid to reading the manuscript. John Azar was an early booster; he read the work carefully and offered useful advice on ways and means of bringing the book to the attention of publishers.

Mary Sanseverino was an early reader of the manuscript; hers remains one of the most thoughtful and comprehensive responses to it. At a key time, Mary's encouragement buttressed my conviction that my project was a winner.

Wayne Ralph provided another generous reading of the manuscript, pointed out a blunder or two, and taught me a good deal about the obstacles I could expect to face in motivating a publisher to take on the project—and the pitfalls I might encounter on the journey to completion.

One more WFA—PCB member, Barry Gough, read the manuscript carefully, offered helpful advice on ways of improving it, and, most important, recommended the project to Heritage House, a recommendation that had the desired effect and for which I am very grateful.

I owe special tribute to Ronald Caplan of Breton Books in Nova Scotia. It was Ron, in the summer of 2015, when health issues compelled me to give up a season at my beloved summer Shangri-La in Cape Breton, who said the right thing at the right moment: that the most worthy use of the time I would otherwise spend in Nova Scotia would be to apply myself to the task of writing this book. Without his timely exhortations, this book would simply not exist. For Ron's excellent and persuasive intervention, I will always be grateful.

Doris MacLeod proved not just a loyal promoter of the project but an assiduous, careful, thorough proofreader. She detected a number of missteps that had escaped my eye and thus spared me the embarrassment that would have arisen had the errors not been corrected before the manuscript went out into the wider world.

My gratitude extends to others who have read the manuscript, offered comments, provided encouragement, rendered assistance, or given advice on navigating a course through troublesome book-publishing shoals: Tom Anderson, Paul Ferguson, Judith Hunt, Naomi Jewers, Tim Leadem, David MacDonald, Michael Nelson, Darcy Squires, Sarah Van Dishoeck, Yvonne Van Ruskenveld, Tom Volkers, Mike Whitney, Bruce Whittington.

A number of people at Heritage House merit my gratitude and appreciation. I am indebted to publisher Rodger Touchie for taking a chance on a largely unknown writer, to senior editor Lara Kordic for her generous and sympathetic response to the manuscript, to copyeditor Kari Magnuson for her assiduous attention to detail and for spotting blunders that had escaped my own and others' attention, to Jacqui Thomas for a book design I regard as beautiful, to Karla Decker for careful proofreading, and to Leslie Kenny for her helpful advice on ways and means of expanding the audience for this book. To all of you at Heritage House I offer heartfelt thanks.

Finally, this: For years I had daydreamed about making a pilgrimage to the battlefields of Flanders and France, to see the places where a dozen of my relatives fought and bled, and where six lie in military graves. It was my wife, Janice Brown, who in 2005 seized the initiative and decided that we would not only make the journey that year but that we do so, fittingly, by bicycle. She has been with me in each of my subsequent circuits of the Western Front.

In 2011 it was Janice who suggested we plot a course across the country aimed at delivering us to as many soldier-bearing war memorials as we could arrange to see, and when that venture proved successful, shared further monument-seeking journeys in the subsequent years. Jan accompanied me on all the voyages that culminated in this book, shared in my contemplation of every one of the monuments addressed in it, was the first individual to urge a book upon me, and was my attentive, supportive, constructive companion throughout the process, from conceiving the book to completing a manuscript. Among all the people whose support, encouragement, and advice have contributed to this project, none stand taller than Janice Brown.

\mathscr{S}OURCES

A RANGE OF PRINTED AND electronic sources have been instrumental in enabling me to produce this book.

I have read widely about Canada's part in the Great War, but a small number of sources must be singled out as having specifically helped with this project.

In 2010, after a bolt of inspiration struck me at Westville, Nova Scotia, I faced an abyss of ignorance: I knew only a little about war memorials. How could I find out more?

At the local library I made a very good start: I found a copy of Robert Shipley's *To Mark Our Place: A History of Canadian War Memorials* (1987). Shipley provided a good sense of the big picture of war memorials in Canada and an introduction to some of the principal artists who produced them. What's more, he delivered a valuable appendix of monument locations across Canada. This enabled me to begin assembling the list of monuments I wished to target in my cross-country travels.

In *Death So Noble: Memory, Meaning, and the First World War* (1997), Jonathan F. Vance provided a scholarly and highly illuminating treatment of Canadian attitudes toward war, war memory, and commemoration.

Among the many books treating Canada's role in Flanders and France, the one that best enabled me to understand the experience of the ordinary soldier on the front lines was Desmond Morton's *When Your Number's Up: The Canadian Soldier in the First World War* (1993).

Tim Cook's two-volume history—*At the Sharp End* (2007) and *Shock Troops* (2008)—is a thorough, highly readable treatment of Canada's part in the war. I turn to these whenever I want to be refreshed about details of a given campaign of the war.

Though long out of print, *Silent Witnesses*, by Herbert Fairlie Wood and John Swettenham (1974), is still a useful guide to the British

military cemeteries having a concentration of Canadian burials of the Great War.

Will R. Bird's memoir of the war, *And We Go On* (1930), is one of the finest soldier's-own accounts of life on the front lines.

Victoria Baker's *Emanuel Hahn and Elizabeth Wyn Wood: Tradition and Innovation in Canadian Sculpture* (1997) gave me some broad perspective on the art and artistry of the sculptor whose monument at Westville inspired the mission culminating in this book.

James H. Gray's *The Roar of the Twenties* (1975) includes a detailed account, "The Battle of the Winnipeg Cenotaph," of Emanuel Hahn's trials at Winnipeg.

The text of the letter from Cliff Bowes to his mother, excerpted in Chapter II, was reproduced in *Legion Magazine*, July 11, 2013. The text of the letter from Irene McMullin, excerpted in Chapter IV, appears in *The City of Sarnia War Remembrance Project*, 2014.

Several online sources have proved invaluable, chief among them the Great War databases of Library and Archives Canada (LAC). Especially useful have been these four:

1. Soldiers' service files: bac-lac.gc.ca/eng/discover/ military-heritage/first-world-war/first-world-war-1914-1918-cef/Pages/search.aspx

2. Battalion war diaries: collectionscanada.gc.ca/ archivianet/02015202_e.html

3. Death registers: collectionscanada.gc.ca/microform-digitization/006003-110.02-e.php?&q2=28&c2=&b2=&t2=&sk =0&brws_s=&PHPSESSID=pf868q7td101us1usidkvu8pl1

4. Commonwealth war graves registers: collectionscanada. gc.ca/microform-digitization/006003-130-0009-e.html?PHP SESSID=ngmpod5vuvu59jhk7dpod6bom5

Equally essential to the LAC databases is the casualty database of the Commonwealth War Graves Commission: cwgc.org/find-war-dead.aspx

Several Canadian databases are devoted to building and maintaining records of Canadian war memorials. Some of the most useful:

1. Veteran Affairs Canada National Inventory of Canadian Military Memorials: veterans.gc.ca/eng/remembrance/memorials/national-inventory-canadian-memorials

2. "We Will Remember": War Monuments in Canada: cdli.ca/monuments/index.htm

3. Nova Scotia Monuments: Photographs of Military Memorials in Nova Scotia: ns1763.ca/remem/military-memorials.html

INDEX

Italics indicate photographs

192